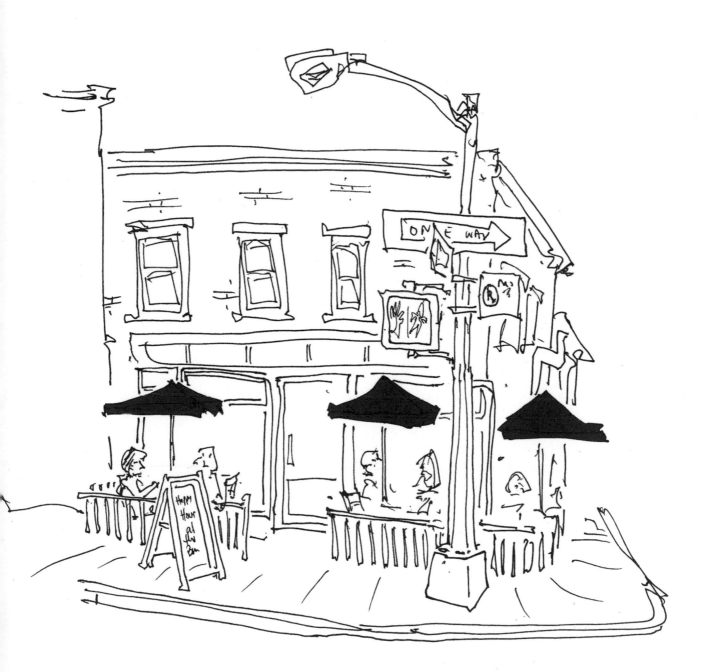

To Sarah, Aurora, and Isis—
my sun, air, and water

Editor: Holly Dolce
Designer: John Gall
Production Manager: Kathleen Gaffney

Library of Congress Control Number: 2018936289

ISBN: 978-1-4197-3445-8
eISBN: 978-1-68335-491-8

Printed and bound in China
10 9 8 7 6 5 4 3 2 1

Abrams Image books are available at special discounts when
purchased in quantity for premiums and promotions as well
as fundraising or educational use. Special editions can also
be created to specification.

For details, contact specialsales@abramsbooks.com
or the address below.

Abrams Image® is a registered trademark of Harry N.
Abrams, Inc.

ABRAMS The Art of Books
195 Broadway, New York, NY 10007
abramsbooks.com

ALL THE RESTAURANTS IN NEW YORK

JOHN DONOHUE

ABRAMS IMAGE, NEW YORK

CONTENTS

It takes a special magic to run a successful restaurant, and sometimes the spell only lasts so long—a few places may have closed but they remain enchanting.

INTRODUCTION

New Yorkers have a unique relationship with cooking. I have a friend from Manhattan whose girlfriend (now his wife) used her kitchen as an extension of her closet. She stored her sweaters in her oven and turned it on so rarely that Con Edison called to see if she wanted the gas turned off entirely. She said yes. Apartments here come furnished with empty refrigerators and it's almost a point of pride to keep them that way. Kitchen drawers used to be stuffed with takeout menus (before the rise of the Internet, at least), and though smart phones and apps have changed the process of ordering, the mentality remains the same. There's little New Yorkers love more than having someone else prepare a meal for them.

Perhaps that's because, with our nonstop schedules and the constant stress of making it here, we turn to restaurants for something more than food alone. The word "restaurant" comes from the French *restaurer*, which means "to restore," and it's a meaning that most New Yorkers take deeply to heart. It helps, too, that there's probably more space in a restaurant dining room (to say nothing of more bathrooms) than in most apartments. A few hours at a good restaurant with good company can do wonders to heal the psychic bruises of a hectic week. And there are never any dishes to do.

The best restaurants—measured by beyond what comes out of the kitchen—rise to a higher place. We visit them for special occasions, such as first dates, to mark a promotion, an engagement, or monumental birthday. This book is a collection of those places. There are about 24,000 restaurants in our city of 8.6 million people, so I might have missed a few, but the ones in here are among the most beloved. Some are as important as our friends and family. In fact, they are probably the only places where we will actually see our friends or family.

I wanted to celebrate the connections we have to these places because I discovered that drawing connects me to a better part of myself. Drawing takes me out of my head and into the present moment more fully than anything else. I draw in ink, from life, without corrections, so the drawings are a recording of a moment in time. It takes me about twenty minutes standing on a street corner to finish the ink drawings. Later I add one color using the computer. My spare and loose style lets the viewer fill in the details of the place from their memory, perhaps taking them back to a cherished moment, or inspiring a future rendezvous with pleasure. It is an honor to present my drawings to you here.

CAFE LUXEMBOURG

200 W. 70th St.

A scorching-hot spot when it opened in 1983, it continues to cast a sophisticated glow across the Upper West Side.

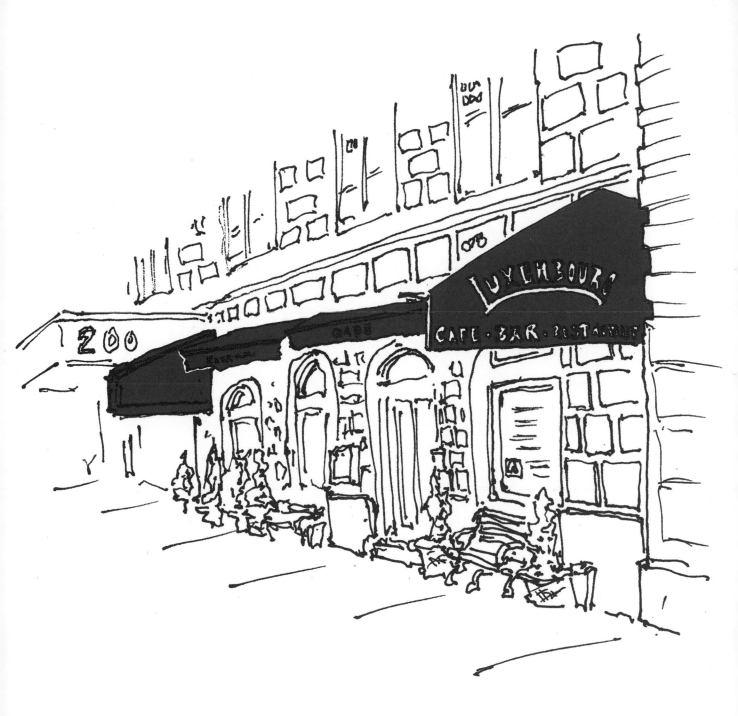

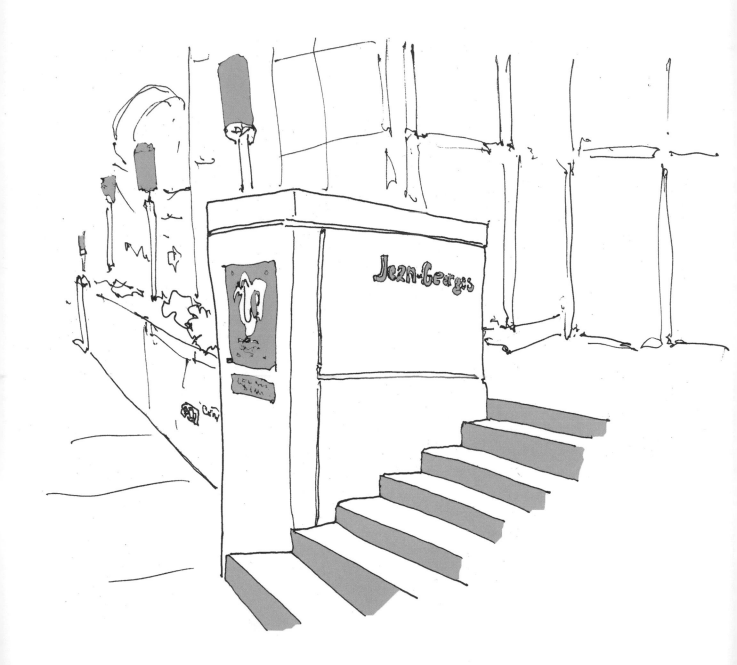

JEAN-GEORGES

1 Central Park W.

Fine dining of the finest order

MAREA

240 Central Park S.
Marea, which is Italian for
"tide," lures you in with seafood
in a refined setting.

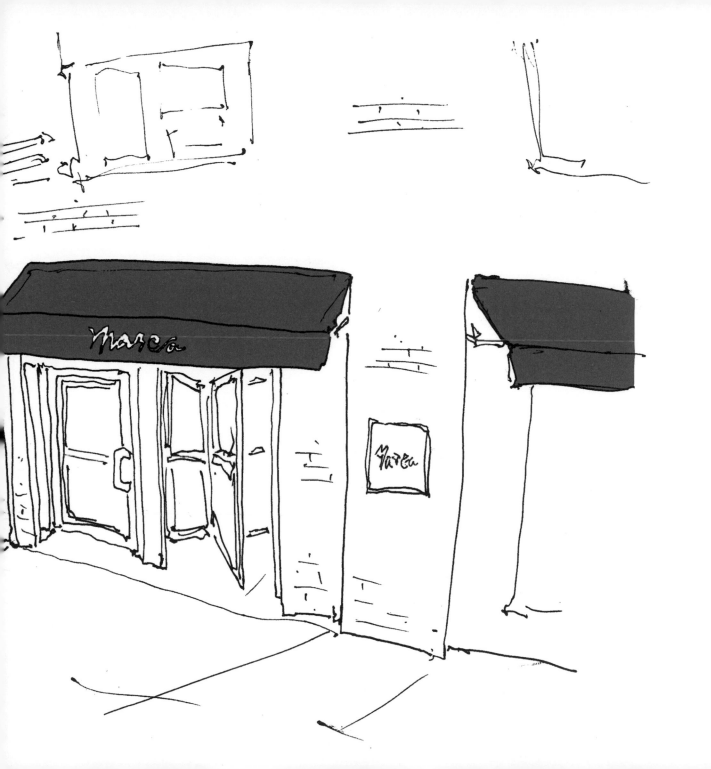

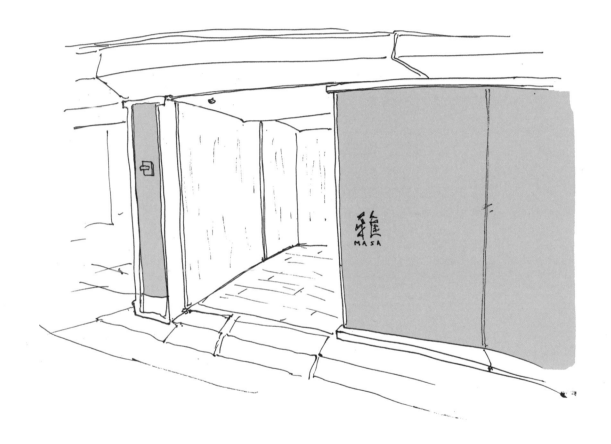

MASA

10 Columbus Cir.

Less is so much,
much, much more.

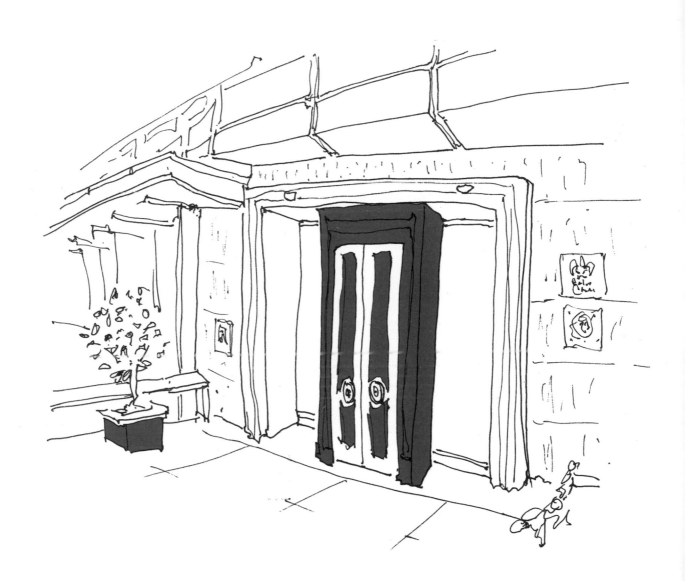

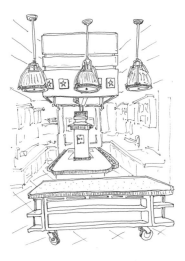

A pre-service moment behind the scenes at Per Se.

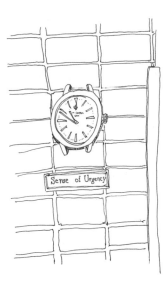

These clocks are on the walls throughout the vast Per Se kitchen.

PER SE
10 Columbus Cir.

Having died twice (and been twice resuscitated during a nine-hour operation), following a serious motorcycle accident in 2005, and enduring over seven years of operations, I defied doctors' predictions that I wouldn't walk again unaided. Last year, on my first time traveling from Scotland to New York with my son we had a very active sightseeing holiday. We decided we had to experience a three–Michelin star restaurant. Per Se was our choice. And what a choice it was! This was fine dining at a whole new level. The view from the dining area out toward Central Park and the New York skyline catching the sunset made this dining experience even more unique. The icing on the cake for us was being invited to meet the chef and his team and to see the kitchen. The atmosphere in there was so relaxed that there was an almost effortless flow of efficiency. Respect to everyone who made this my best dining experience so far. —Brian Smith

RAO'S

455 E. 114th St., at Pleasant Ave.
It's "RAY-ohz," so now you know
how to pronounce that place where
you'll never get a table.

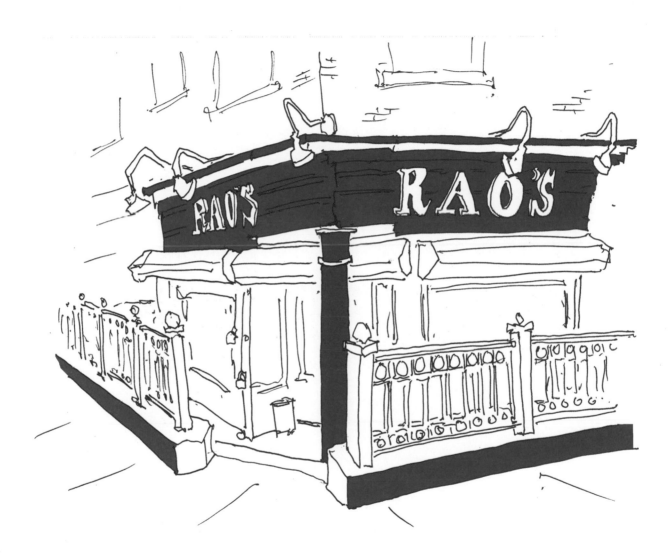

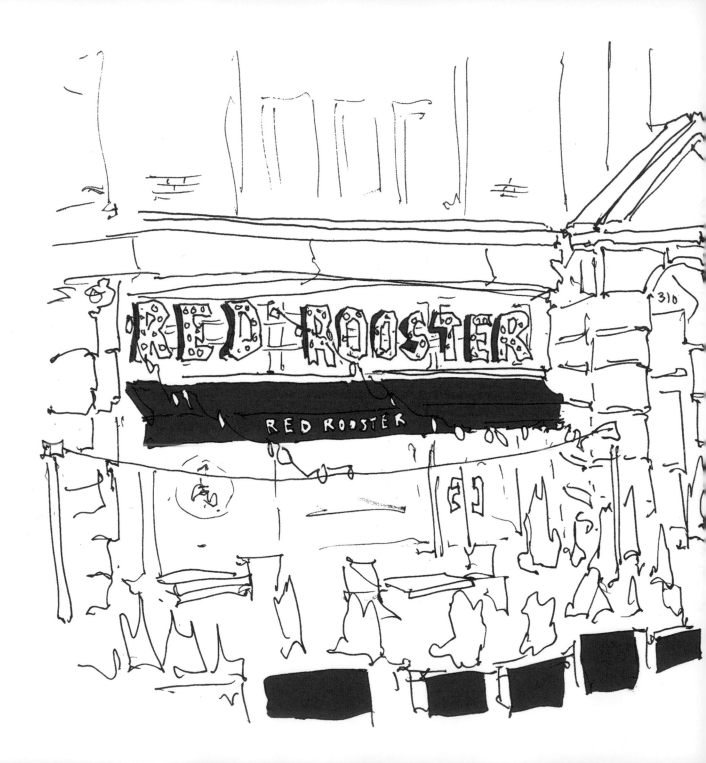

RED ROOSTER
310 Lenox Ave., between
125th and 126th Sts.
Good vibes from Marcus
Samuelsson

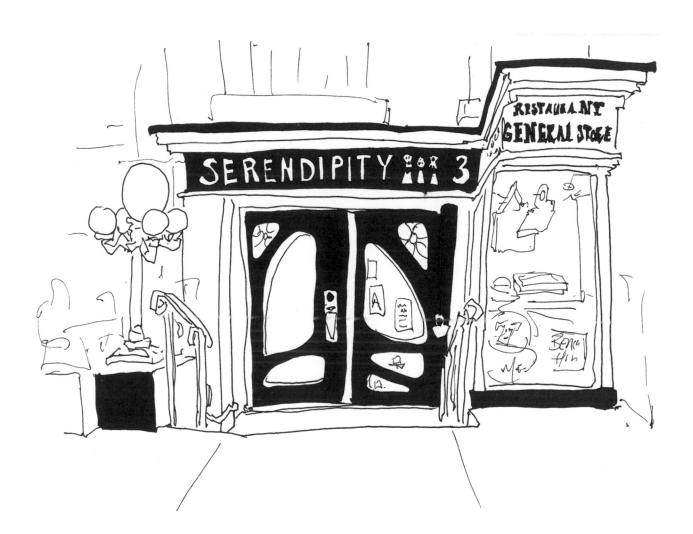

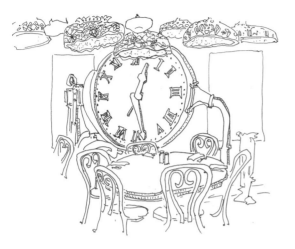

An *Alice in Wonderland*–sized clock fills one room.

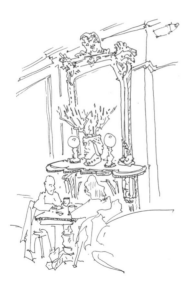

Upstairs by the fireplace is the table where part of the movie *Serendipity* was filmed.

SERENDIPITY 3
225 E. 60th St.

Patch Caradine, Calvin Holt, and I loved theater, dance, and art. We were young and innocent and all shared a need for income. So we decided to open a coffee shop and serve pecan pies. We got a great big 1930s espresso machine that was a steaming monster and frightened me to death. We threw a grand opening party with 150 guests. The next day, no one came. There wasn't much profit for three people to survive on selling thirty-cent espressos and sixty-five-cent pies. We needed to do something. Patch was from down south and loved blended drinks. So we asked ourselves, "What's the one thing in the world everyone likes? Chocolate!" We experimented and came up with Frrrozen Hot Chocolate, a mix of fourteen different chocolates blended with milk and ice. It was an instant hit, and the rest, shall we say, is history. —Stephen Bruce, who founded Serendipity 3 with his friends in 1954

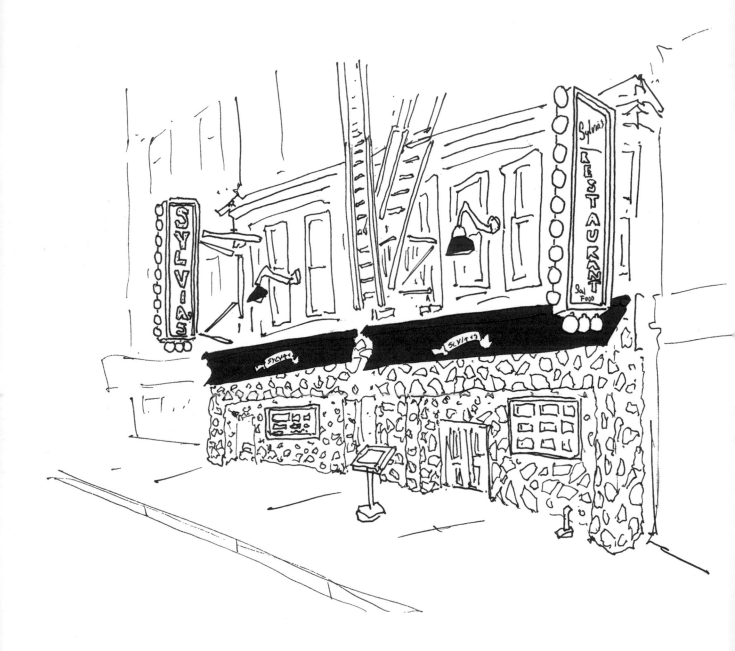

SYLVIA'S RESTAURANT

328 Malcolm X Blvd.,
between 126th and 127th Sts.
The home of the late Queen
of Soul Food.

TAVERN ON THE GREEN

67th St. and Central Park W.

Sheep used to sleep here.

'21' CLUB

21 W. 52nd St.

Toys hanging from the ceiling
at this famed former speakeasy
are one clue it will always be a
playground for grown-ups.

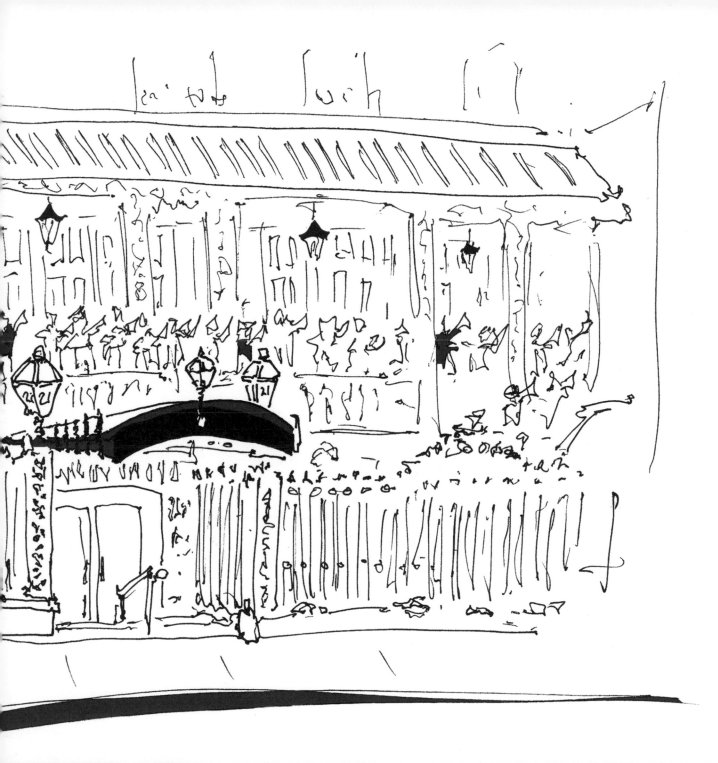

AGERN

89 E. 42nd St.

An unassuming corridor in
Grand Central leads to Claus
Meyer's Narnia of the North.

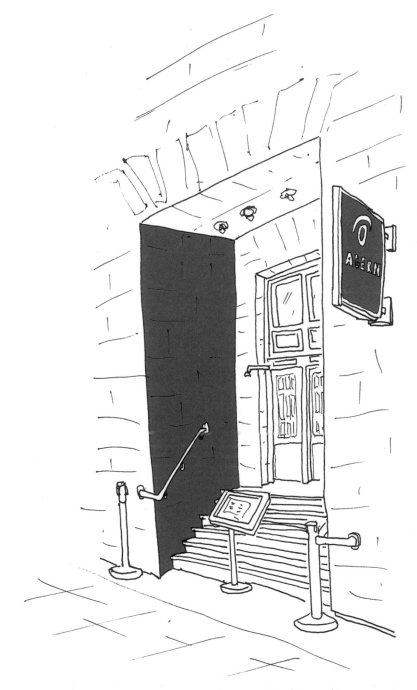

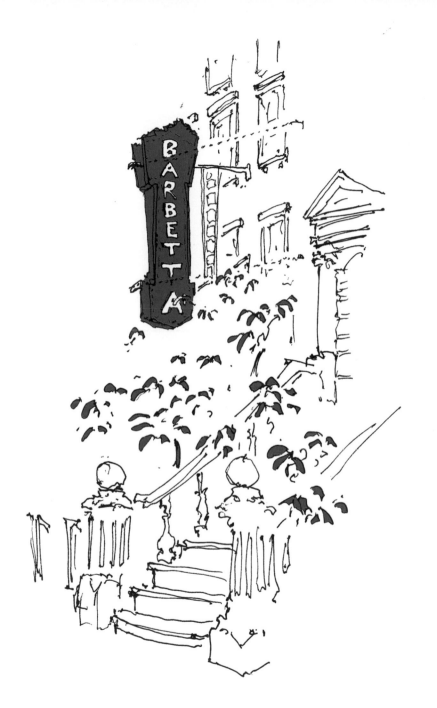

BARBETTA

321 W. 46th St.

The first restaurant in New
York to serve risotto and
polenta, import an espresso
machine, and have its own
truffle hounds

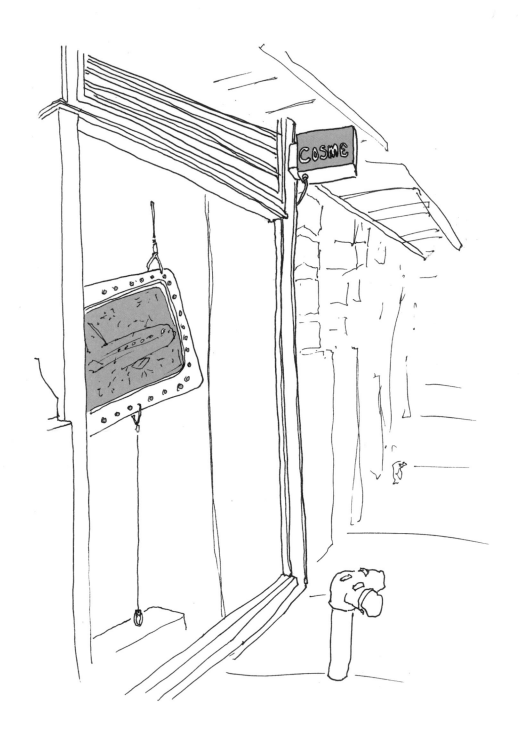

COSME

321 W. 46th St.

**Enrique Olvera's
world-beating Mexican**

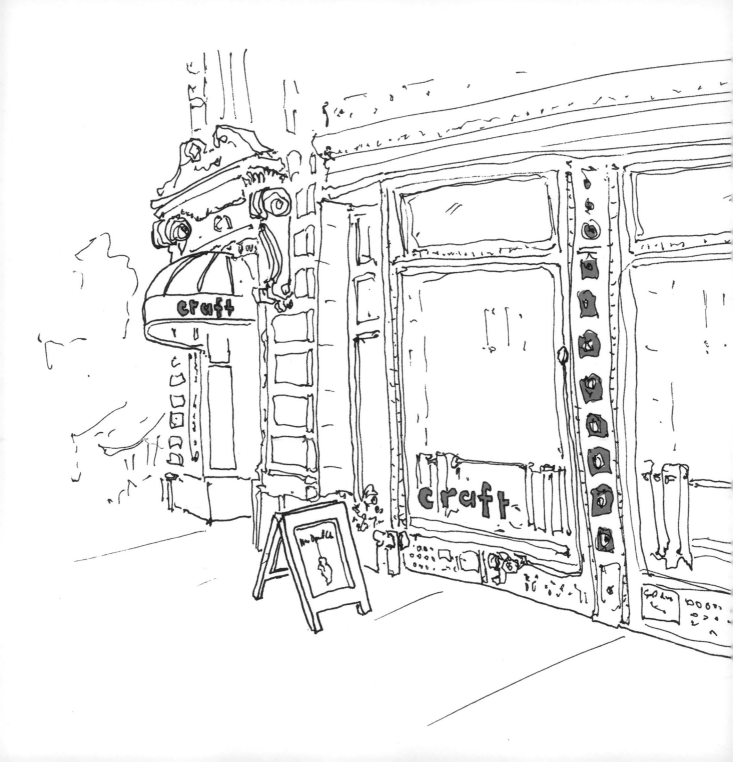

CRAFT

43 E. 19th St.

Gramercy Tavern co-founder
Tom Colicchio's never-ending
dinner party

DANIEL

60 E. 65th St.

Grand French cooking

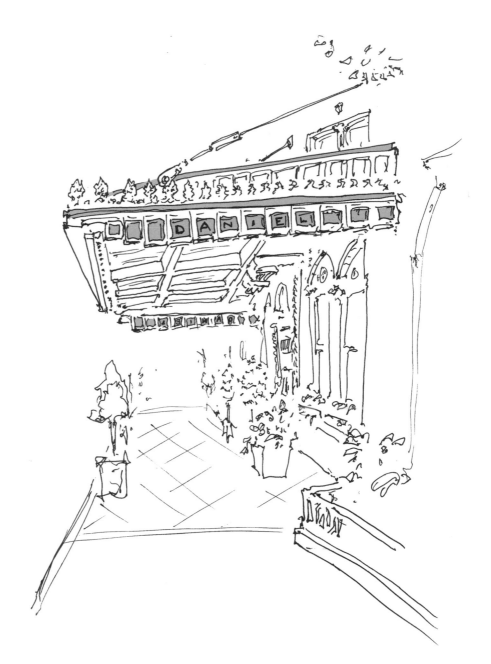

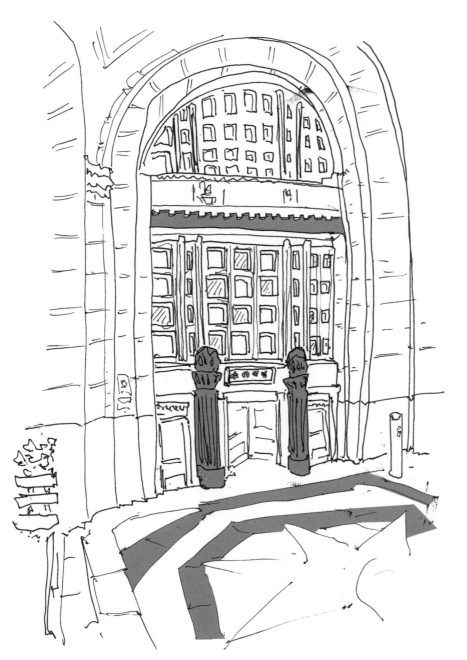

ELEVEN MADISON PARK
11 Madison Ave., at 24th St.
Winner of the World's Best
Restaurant title for 2017

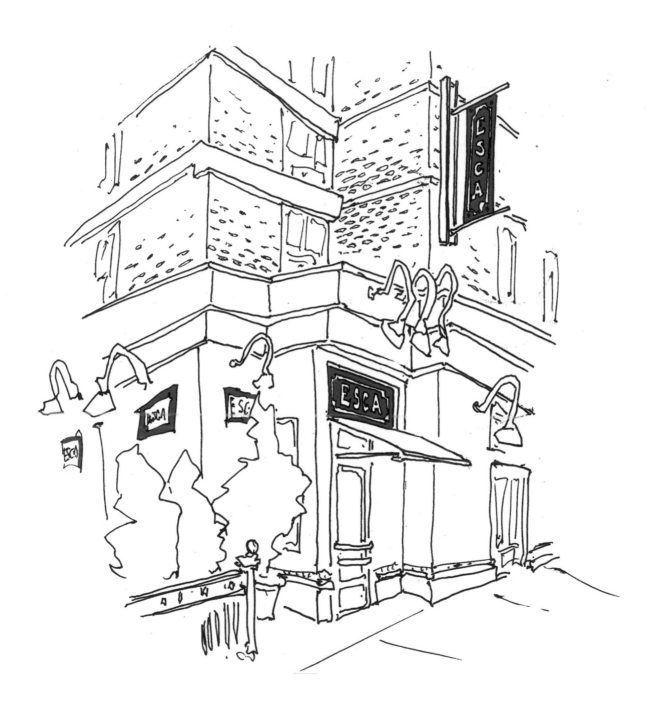

ESCA

402 W. 43rd St.

The name is Italian for "bait."

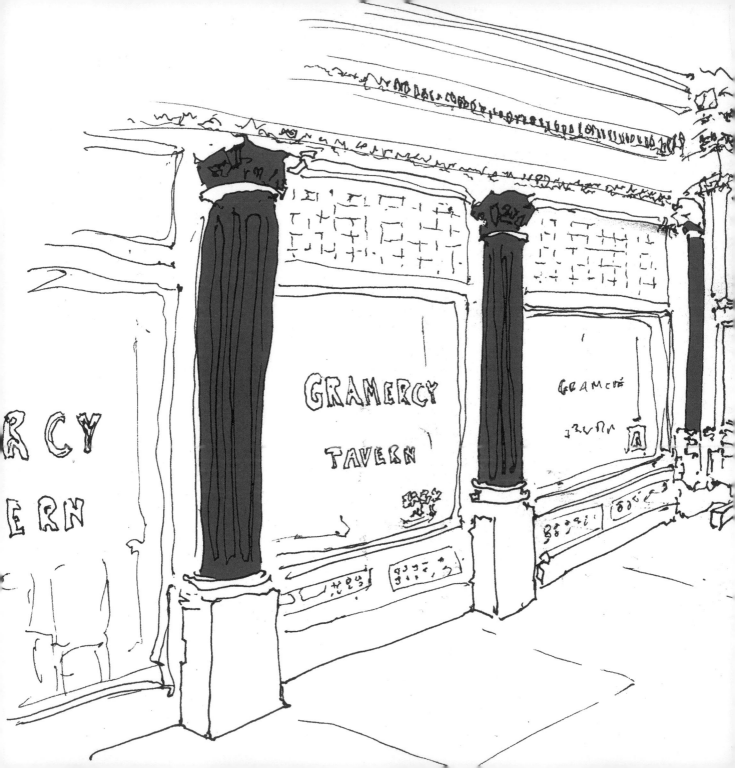

GRAMERCY TAVERN
42 E. 20th St.
The standard-bearer for
timeless hospitality

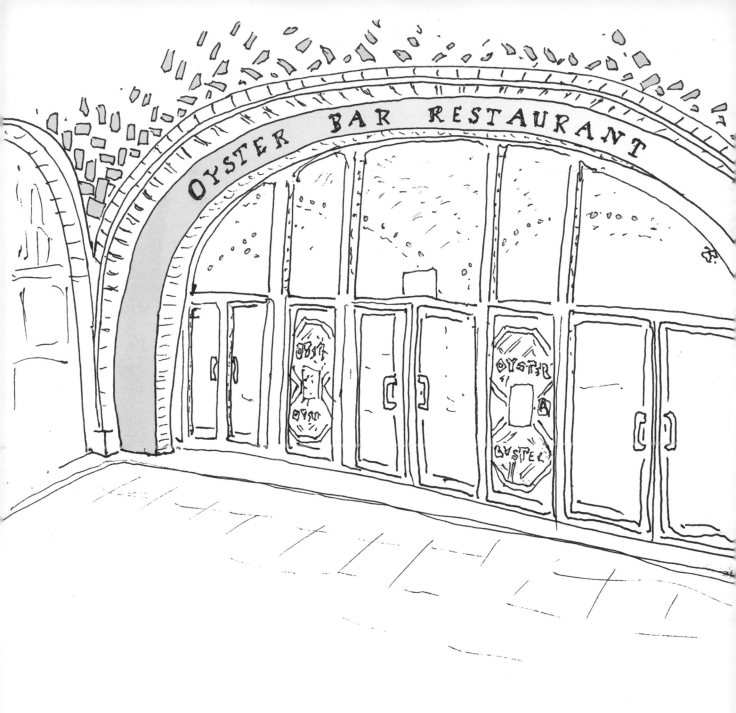

GRAND CENTRAL OYSTER BAR
89 E. 42nd St.

When my husband and I first met and were dating, we would often meet at Grand Central at either the beginning or end of the night. You wouldn't normally think of an underground restaurant as a place you'd be drawn to. But what is better on a date than wine and cold oysters at a city bar, where you don't even notice you're in one of the busiest transit hubs in the world? —Christine La Porta

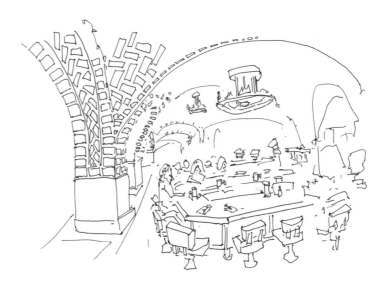

Ask for the sandwich menu at the Oyster Bar's lunch counter if you want to save a few dollars.

JOE ALLEN
89 E. 42nd St.

When I finished graduate school in the late sixties, I came to New York because I wanted to be an actor. I taught school for three years, but I couldn't get to auditions or acting classes because the job took too much of my time. Eventually a scene partner suggested I try waiting tables at a restaurant that was open mainly at night, and *duh*, a light bulb went off. I made the rounds of restaurants in the theater district, Joe Allen being one of them, and I was lucky enough to be hired there as a waiter and later a bartender. I spent three years there while I studied and auditioned, and Joe's afforded me a lot of time off and enough money to live. I finally got a TV series in 1975 and was able to leave Joe's and support myself as an actor until I retired, in 2007. This picture resonated with me because it includes the steps leading up to Joe's private quarters. Most people take or draw pictures of the steps leading down to the restaurant, but this has the stairs to the right. Why did that bring tears to my eyes? Well, when working there the staff was allowed a half hour to eat between the pre- and post-theater rushes. Most nights, after I ate, I would go outside and sit on those steps to watch people go by. I'd look at the bright lights, thinking how lucky I was to live in New York, but mainly I'd sit there and dream of getting acting work. After I got my first big

job, *The Edge of Night*, for seven years I would go back to Joe's to eat. I would always sit on those steps and say thank you to the ether for my good karma. And thank Joe for helping me, and so many other actors, achieve their dreams.
—Tony Craig

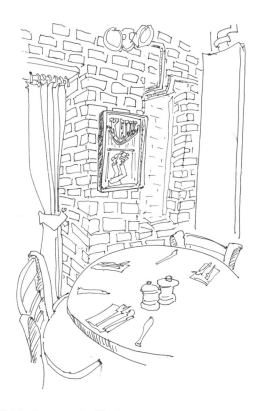

"Kelly," the first poster Joe Allen hung, gets a wall of its own.

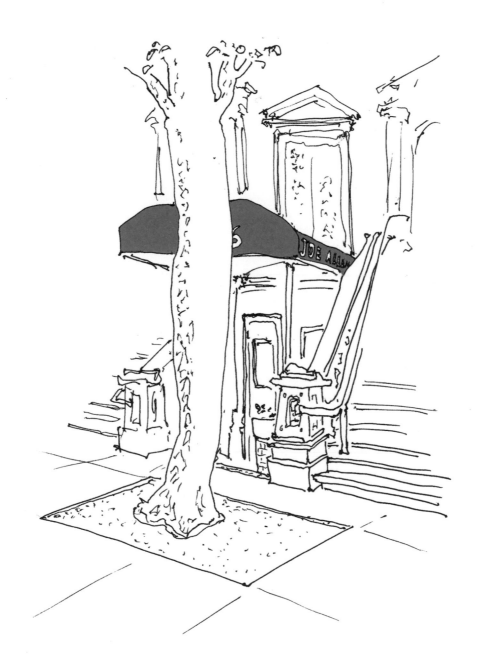

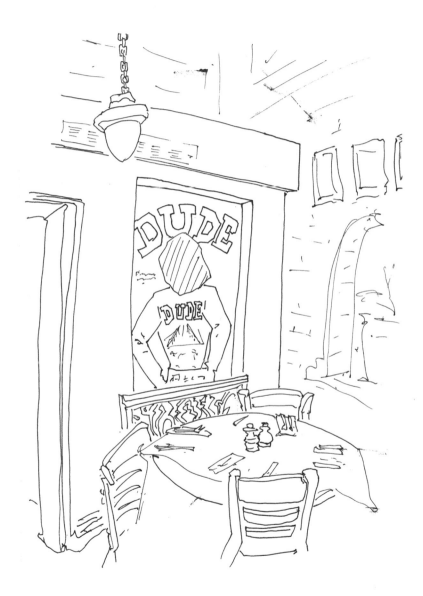

Gerome Ragni's second rock musical, 1972's *Dude*, is a little less famous than his first, *Hair*.

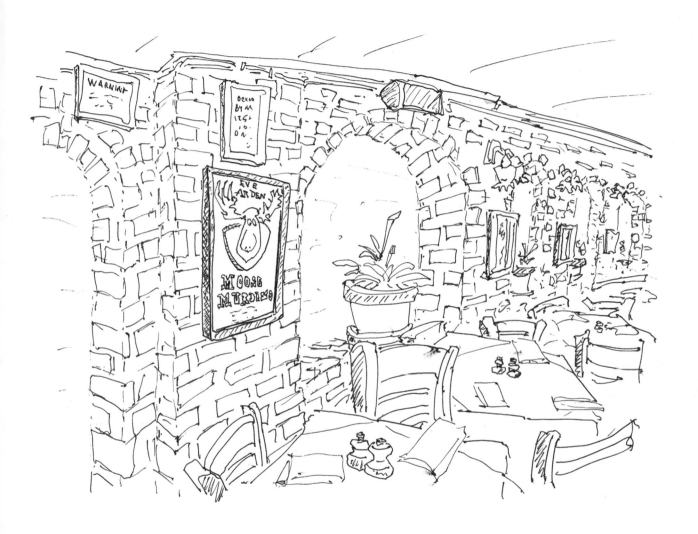

Moose Murders, the 1983 flop by which all other flops are judged, opened and closed on the same night.

KEENS STEAKHOUSE
72 W. 36th St.

I'm old and so have been going to Keens since it was Keens Chophouse, in the seventies. Many years ago, during the Big East Tournament celebration of my alma mater's victory over Georgetown, I was staying in a nearby hotel. I had overtipped the staff by a large magnitude. Bonnie Jenkins, the general manager, called my cell the next day to ask about the very large gratuity; she allowed me to come back and rearrange the numbers so it was only generous but not large enough for a down payment on a house. Another time, a friend was hosting a large group, and bottle after bottle of an expensive red wine was coming to the table. No one kept track of how many. The bill was paid, and a call came a few days later explaining that we'd been charged for one bottle that was ready but never made it to the table. My friend's card was credited back. I trust all establishments do these kinds of things, but I am not certain of that. I love the place and was presented with my own clay pipe and got to sign it upon presentation on a silver tray. I am no Douglas MacArthur, but we both have Keens pipes.
—Bob Moran

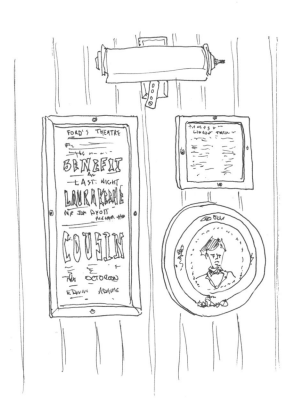

On the second floor hangs the program from Ford's Theatre the night of Lincoln's assassination.

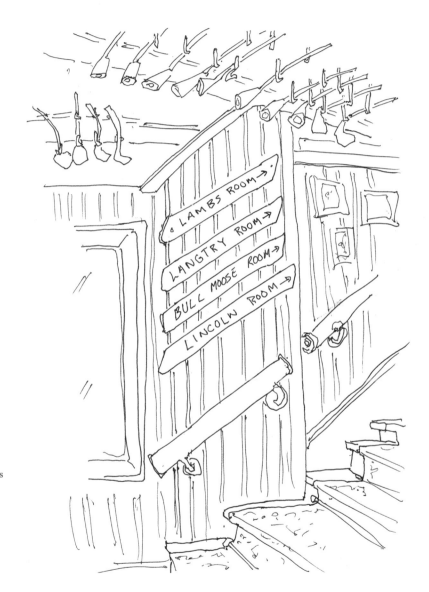

Pipes line every ceiling, upstairs and down, at Keens.

The sign reads:
LAMBS ROOM →
LANGTRY ROOM →
BULL MOOSE ROOM →
LINCOLN ROOM →

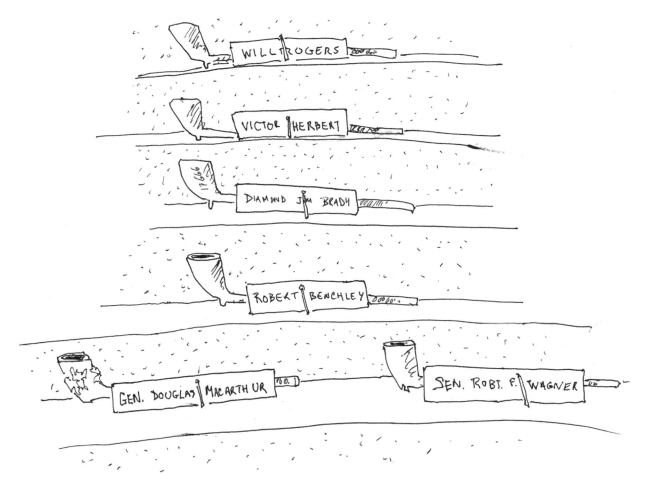

The old pipes of famous patrons are in a tiered vitrine just inside the entrance.

LE BERNARDIN

155 W. 51st St.

The only restaurant in the city to
earn four stars from the *New York
Times* in all four reviews across its
two-decade-plus history

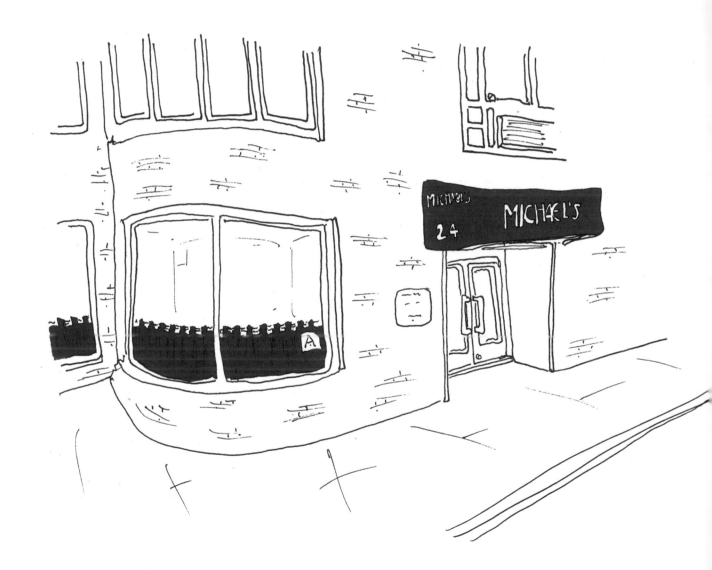

MICHAEL'S

24 W. 55th St.

Opened by a prophet of
California cuisine, it became
a media power-lunch canteen.

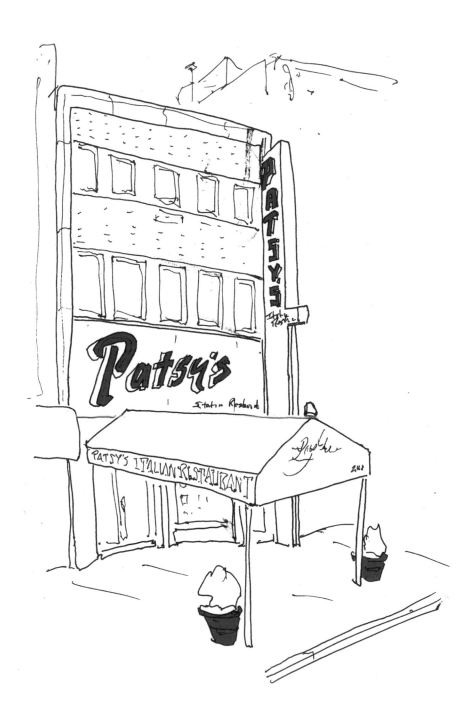

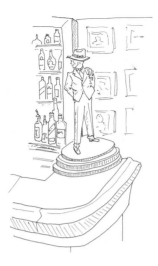

A statue of Ol' Blue Eyes keeps watch over Patsy's from a corner of the bar

The door where Sinatra typically came and went is still upstairs, if you know where to look for it.

PATSY'S ITALIAN RESTAURANT OF NEW YORK

236 W. 56th St.

We would fly into New York from Boston just for dinner at Patsy's when we were dating. The first time was after seeing Sinatra in his comeback—*Ol' Blue Eyes Is Back* in the midseventies. The food was always fabulous, especially the clams casino and the chicken contadina, and the service was wonderful—Vinnie, the head waiter, is still a familiar face at the restaurant today. There were so many "oh my God" moments for us, like the time I held the door for Tony Bennett and the time that we were sitting in the dining room while Frank Sinatra was having a private party upstairs. When we started taking our young daughters to the restaurant, Vinnie made their faces light up with delight when he taught them the Amaretti di Saronno flying cookie wrapper trick—if you don't know it, go ask for Vinnie and have him show you.

—Joan Cucchiara

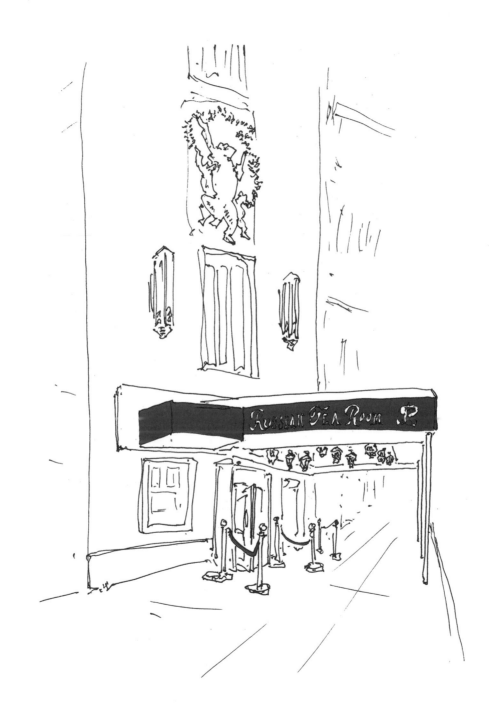

THE RUSSIAN TEA ROOM

150 W. 57th St.

The glittering home of vodka and caviar. Long live the blini!

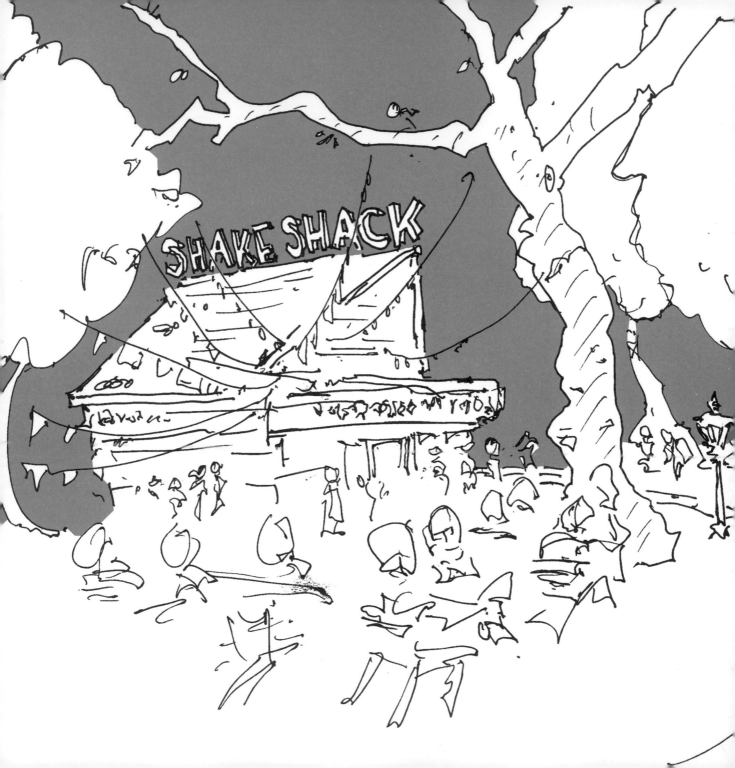

SHAKE SHACK
Madison Square Park, at Madison Ave. and E. 23rd St.

When my now-husband and I first started dating, he lived and I worked close by, so date nights frequently included a walk through Madison Square Park for a burger and a concrete. In wintertime, we seized the advantage of shorter lines—including one particularly memorable dinner alfresco in the February snow, decked out in our winter coats, hoods pulled tight around our faces (and, for warmth, beer instead of milkshakes). There's a certain comfort in recapturing the backyard burger nights of my suburban childhood, and as many apartment-dwelling New Yorkers know, public spaces can quickly become intimate. Shake Shack is our back porch. One spring night last year, my husband and I ventured out for a movie and Shake Shack. The occasion: celebrating reaching my due date for our first child. Friends urged us to go out, to the movies, to dinner, while we still could. As fate would have it, burgers make for good fuel; I went into labor in the early hours of the next morning and my son made his entrance into the world not so long thereafter. We'll take him to the original location, of course, sometime when the line isn't so very long.
—Calli Ray

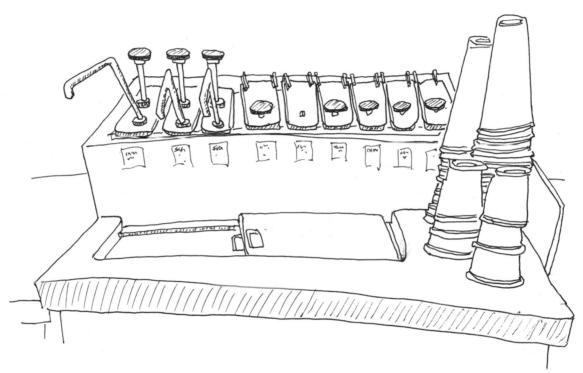

Ice cream with all the toppings is
always ready.

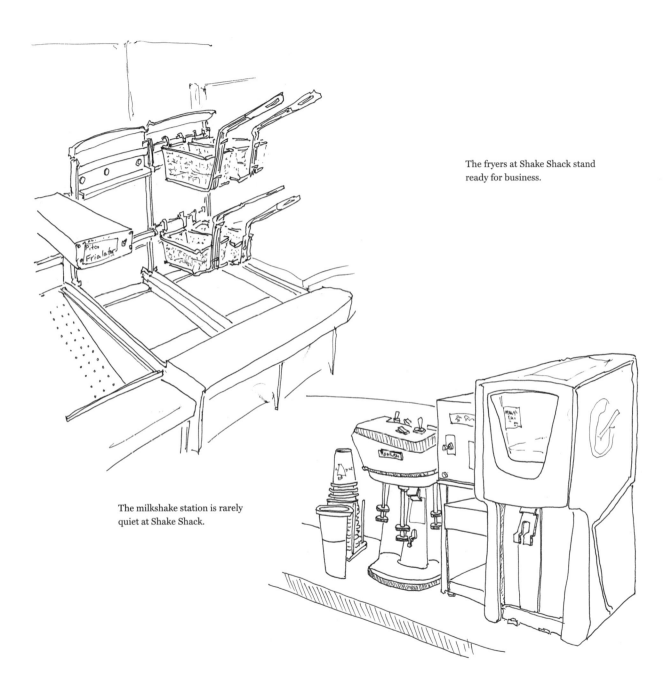

The fryers at Shake Shack stand ready for business.

The milkshake station is rarely quiet at Shake Shack.

SMITH & WOLLENSKY

797 3rd Ave., at 49th St.
With two names plucked
randomly from the phone book
in 1977, TGI Fridays founder
Alan Stillman created a steak
house for the ages.

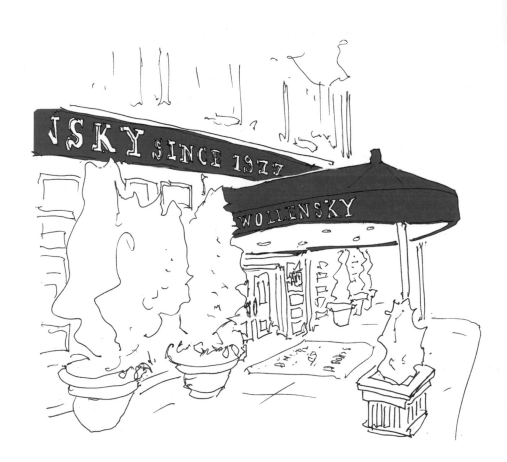

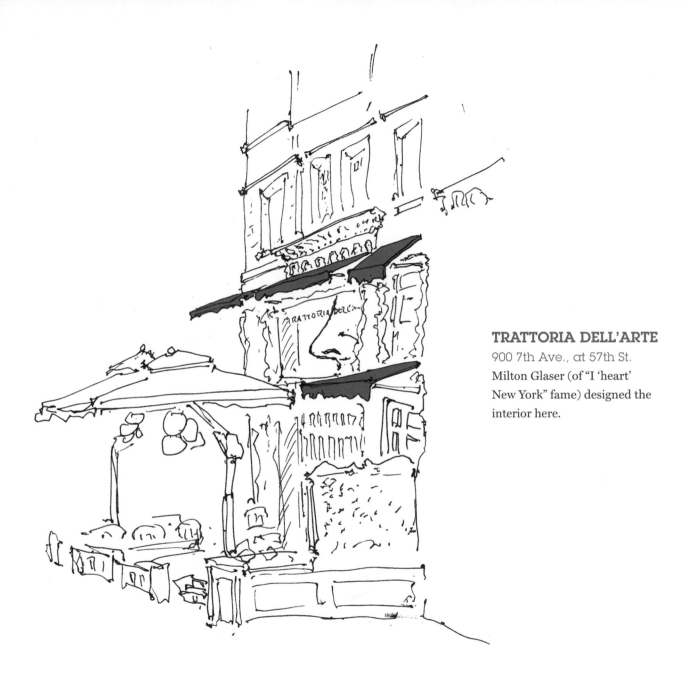

TRATTORIA DELL'ARTE
900 7th Ave., at 57th St.
Milton Glaser (of "I 'heart'
New York" fame) designed the
interior here.

MANHATTAN

GREENWICH VILLAGE

AND

CHELSEA

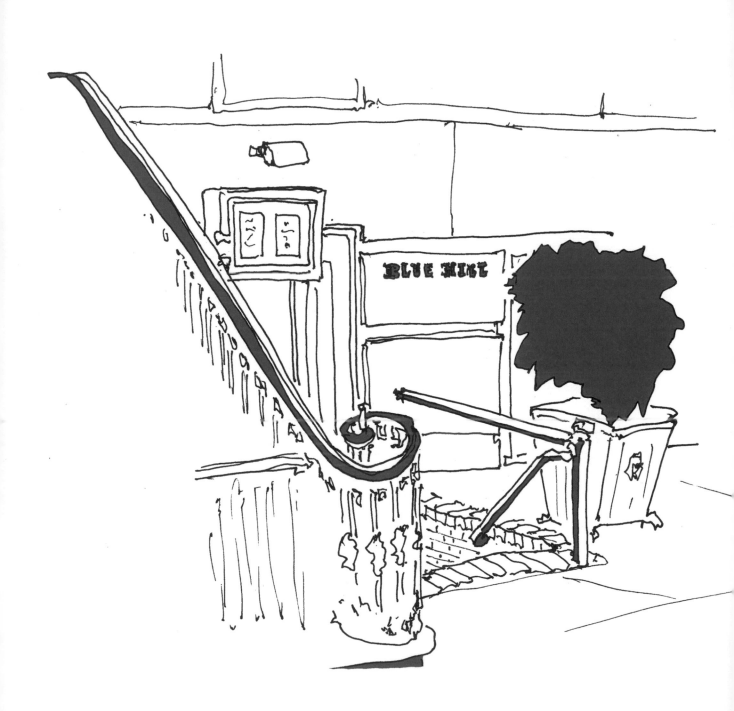

BLUE HILL

75 Washington Pl.
The farmer, chef, and
philosopher Dan Barber's
pied-à-terre

BUVETTE

42 Grove St.

Two years after the California-born chef Jody Williams opened this cozy French café, she set up a successful branch in Paris. That tells you *quelque chose*.

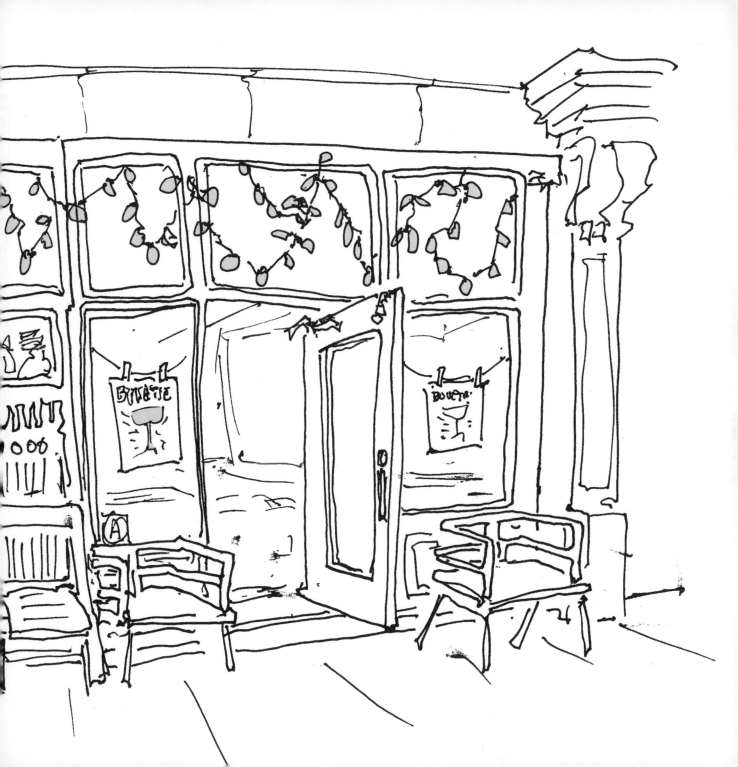

CAFÉ LOUP
105 W. 13th St.

My wife, Roxanne, and I were searching for an affordable spot in the Village within walking distance of our loft at Sixteenth Street and Sixth Avenue. We didn't have much money, so shabby dives were what we looked at. We found a failing dive bar at 18 East Thirteenth Street in December 1976 that was for sale. It was small and seedy, but we hired a friend, Ron Focarino, who I knew from Max's Kansas City, who worked constructing sets for photographers, who could make our new restaurant good-looking and cozy. We named the joint Café Loup for two reasons. I was fairly long-haired and bearded and had worked at a midtown bar and restaurant called Jimmy's, where the other bartenders called me the Wolf Man. Directly across the street was a small French-run bakery called Les Trois Petits Cochons. I thought the three pigs needed a wolf nearby, hence the name. We opened for business on April 7, 1977. We had contrived a French menu, a mistake since we didn't translate dishes on the chalked slate menu. Business was very slow during the first six months. We were on the brink of failure until we changed the menu to English. Nearby businesses—*Women's Wear Daily*, the *Village Voice*, *Forbes* magazine, and Farrar, Straus and Giroux—provided a robust lunch crowd, but evening customers were sparse until my pal Seymour Britchky gave us a write-up in *New York* magazine. We began to attract a clientele of well-known people in the literary, theater, movie, and art worlds: Richard Gere, Jane Curtin, John Belushi, Edward Albee, and many others. We coasted along until the lease renewal had us paying six times higher rent monthly. After twelve years we moved to 105 West Thirteenth, formerly a bar called the Bells of Hell, where I had worked as a fill-in behind the bar before opening Café Loup. The space was much larger, with a longish bar and seats for 110. It needed renovations to get rid of the last tenant's bizarre decor, a French disco that failed. We spent our last day at 18 East Thirteenth on July 9, 1989, and segued to 105 West the next day, July 10. It was an immediate hit, although lunch traffic diminished significantly, proving my theory that the nearest eatery is where to go for lunch. After four years, I surrendered to the stresses of running a restaurant and decided to seek a buyer. Our longtime chef, Lloyd Feit, agreed to take it over with his wife.
—Bruce Bethany (1933–2018), founder of the publishing-world favorite Café Loup, which is currently under even more recent ownership.

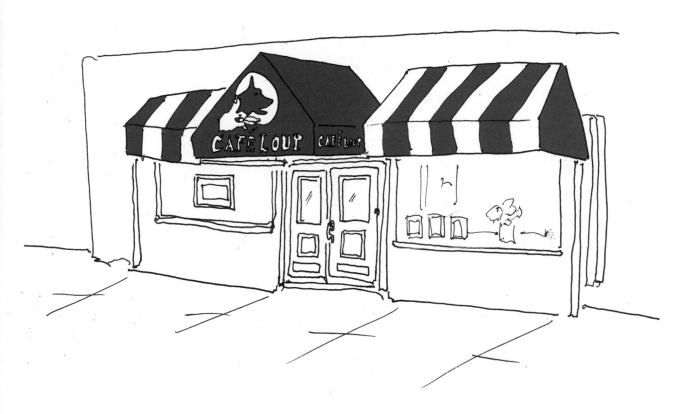

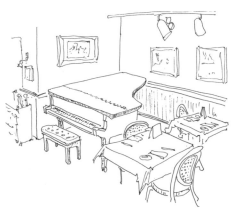

The pianist Junior Mance held
court at Café Loup for years, and
it still presents jazz music.

CARBONE

181 Thompson St.
The theatrical red-sauce
joint of your dreams

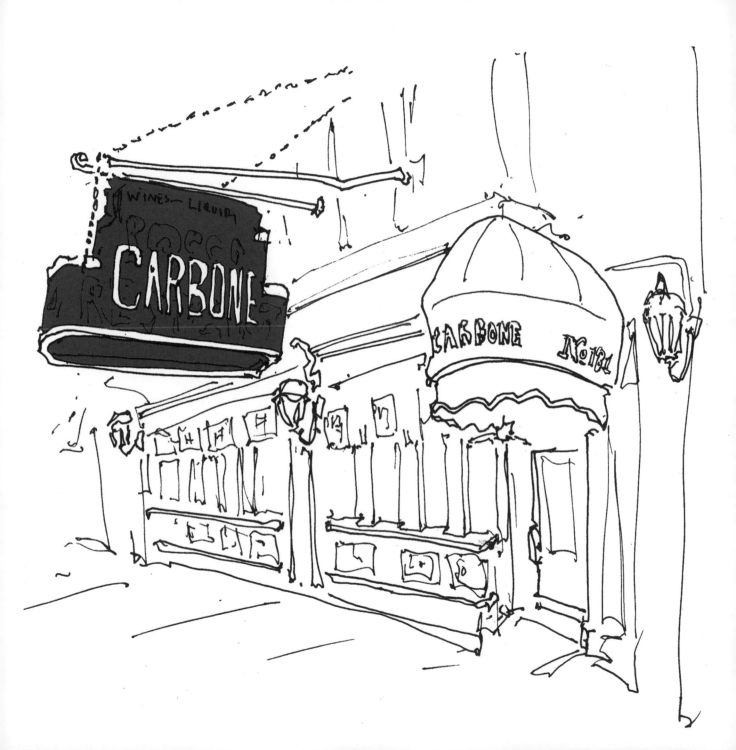

CORNELIA STREET CAFÉ

29 Cornelia St.

Though open since only 1977, it is one of the last remaining links to the Beat Generation.

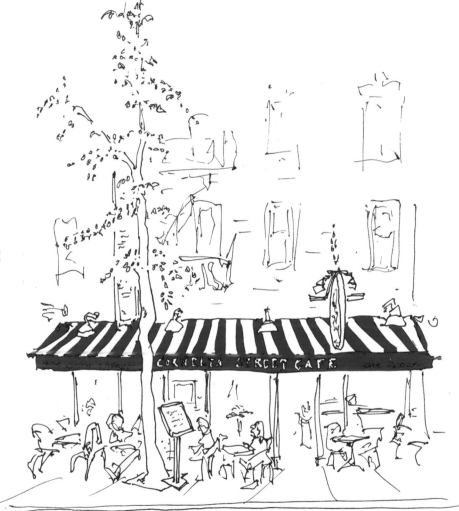

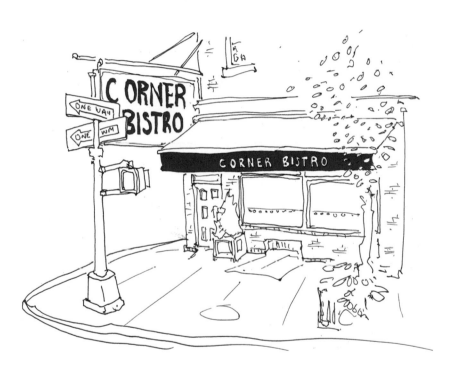

CORNER BISTRO

331 W. 4th St., at Jane St.
Initial-carved tables, beer, and
some of the city's best burgers

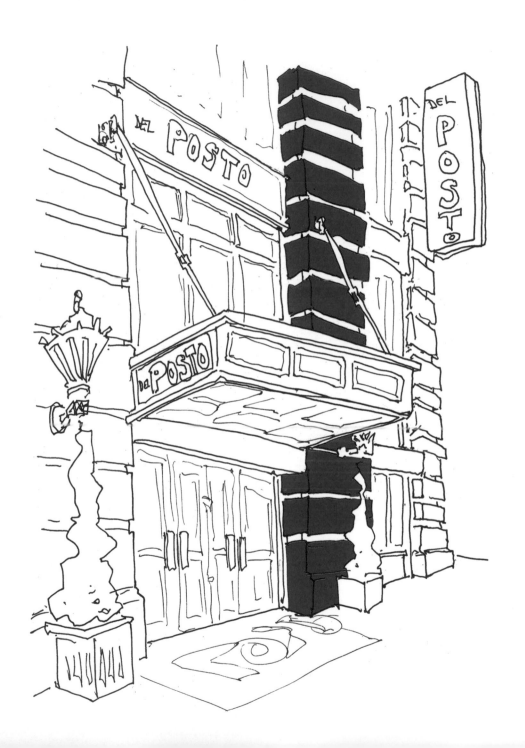

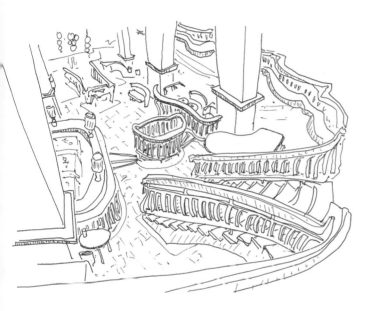

The view from the balcony at Del
Posto is as wonderfully dizzying
as the food.

DEL POSTO
85 10th Ave., at 16th St.

We are fortunate to have built a culture in
which everybody who works here really wants
to be here. There are more than two hundred
people on staff, including several who have been
here from the first year and many who have
done more than five years. I've been here eleven
years. That's a long time in New York City
restaurant years. So as a diner I think the best
way to go is to sit down, trust your captain, and
ask for what they think is the best way to go that
night. When I go to Europe and go out to eat,
I'll tell them I'll have whatever is best, which
relinquishes control, and it takes away a little of
the expectation. That doesn't mean to break the
bank. It's not about the most expensive wine.
It's saying, I want to trust you, that I trust you
know what you are doing.
—Jeff Katz, general manager, Del Posto

I SODI

105 Christopher St.
If you can't get to Tuscany, go
for the light and crispy fried
artichoke hearts.

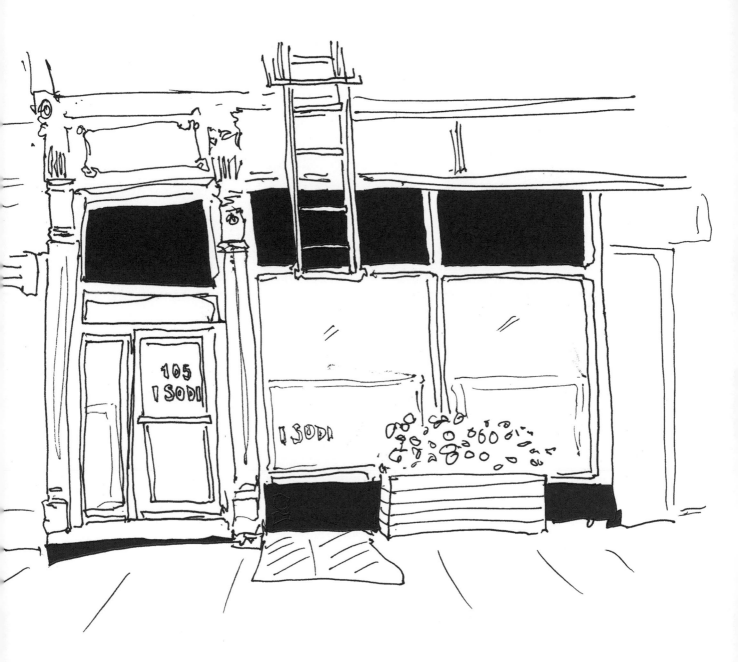

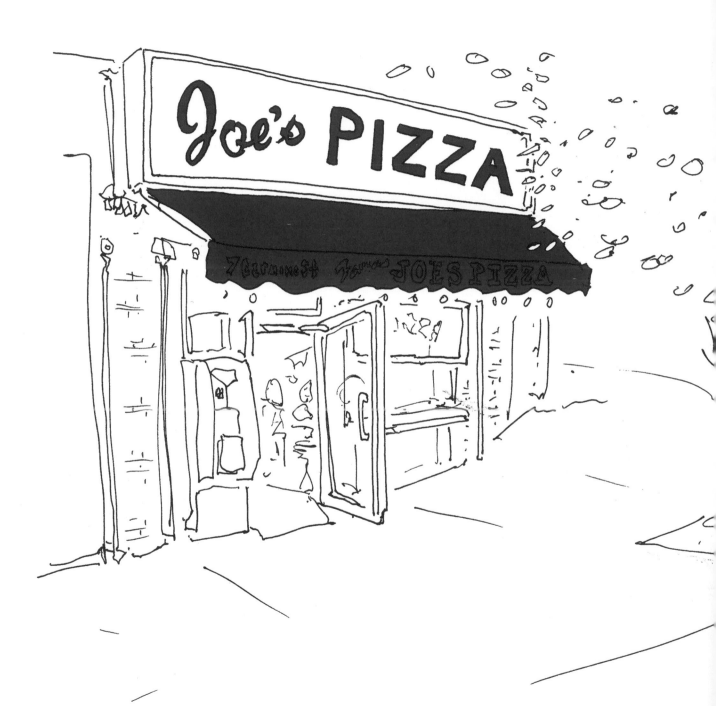

JOE'S PIZZA
7 Carmine St.
Thin slices the old-school way

LITTLE OWL

90 Bedford St.
The wisdom of meatball sliders
and massive pork chops

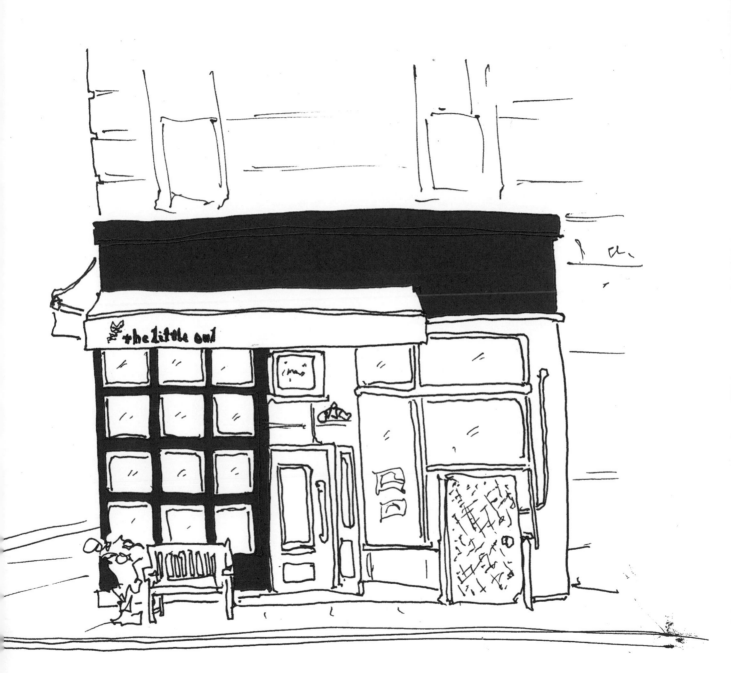

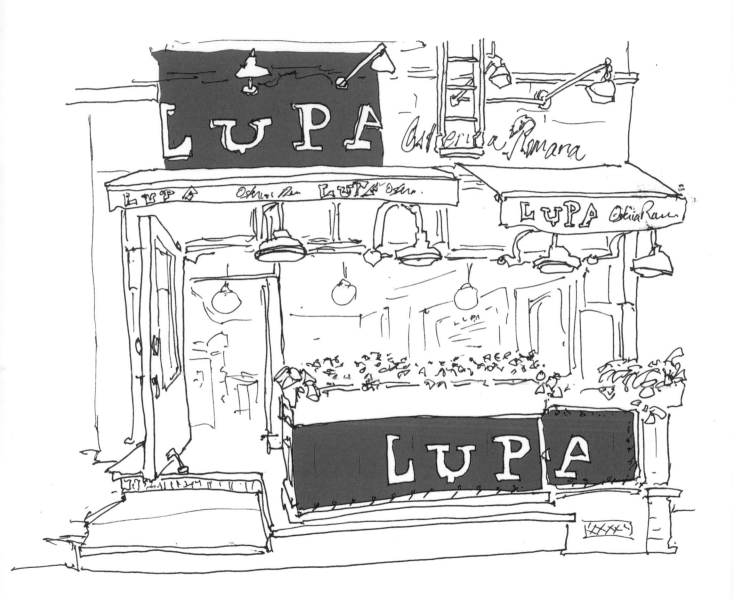

LUPA

170 Thompson St.

The food is Roman, but the
wine list is Italian. Really
Italian, with more than four
hundred selections from
every region in the country.

MAS (FARMHOUSE)

39 Downing St.
(2004–2018)

There's a life to the menu. It changes constantly. Still, if I had to say there was a signature dish, it's the tuna l'Occidental, an appetizer of raw yellowfin tuna that's doused with brown butter and topped with crispy shallots. It's Asian with flavors of the West. I started to think about the technique even before I opened Mas, in 2004. Prior to this I was the chef de cuisine under David Bouley, and on a trip to Japan at that time to the Tsuji Culinary Institute, in Osaka, I learned about various techniques for cooking sashimi. As a matter of fact, the Japanese do all sorts of things to their sashimi. Sometimes they pour hot water on it—which may be used to remove a thick film on the skin—or hot oil, or use hot metal rods. Later, I took these ideas and came up with the dish. When we started out, we used blackfin tuna. Blackfin was a very sustainable option. I sourced fish that was caught with hand lines, which limits the amount of fish you can catch and eliminates bycatch. It is also a smaller variety of tuna, which means it reaches a reproduction age quicker, allowing it to withstand fishing pressure better. I had a fisherman in the Caribbean who would pack them in ice and FedEx them to my door. It worked out well until a confused team of FBI agents showed up in the dining room one day, demanding to see the paperwork for the international fish importer on the premises. I said, "This is a restaurant, not a fish importer." Long story short, my source was based in Trinidad and Tobago, and because I was getting the fish directly, things were complicated. That was quickly the end of that supply.
—Galen Zamarra, who owns Mas (farmhouse) with his wife, Katie

Simple wooden stools and tables in the bar area
at Mas (farmhouse)

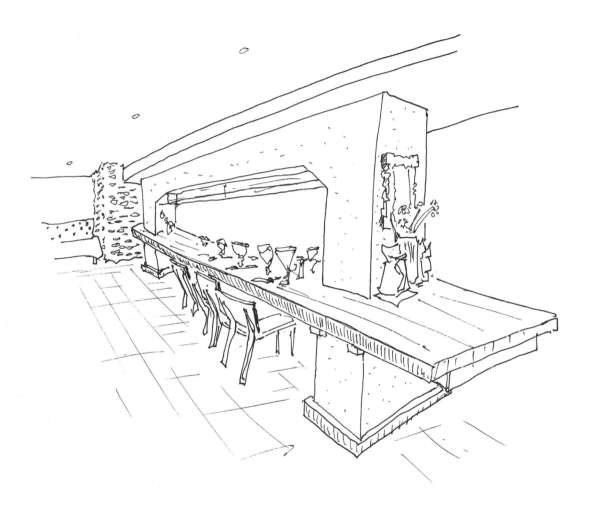

The grand farmhouse table is the centerpiece
of the dining room at Mas (farmhouse).

MINETTA TAVERN

113 MacDougal St.
More marvelous sleight of
hand from Keith McNally,
who returned this legendary
watering hole to glory a few
years ago.

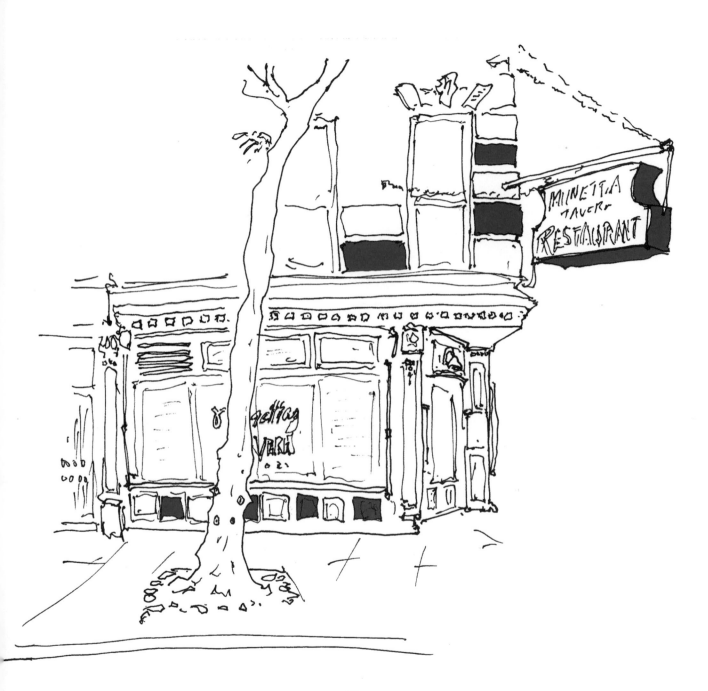

OLD HOMESTEAD STEAKHOUSE

56 9th Ave., between 14th and 15th Sts.
In 1868, Old Homestead broke with local
traditions, by, among other things, offering
silverware to fans of huge portions.

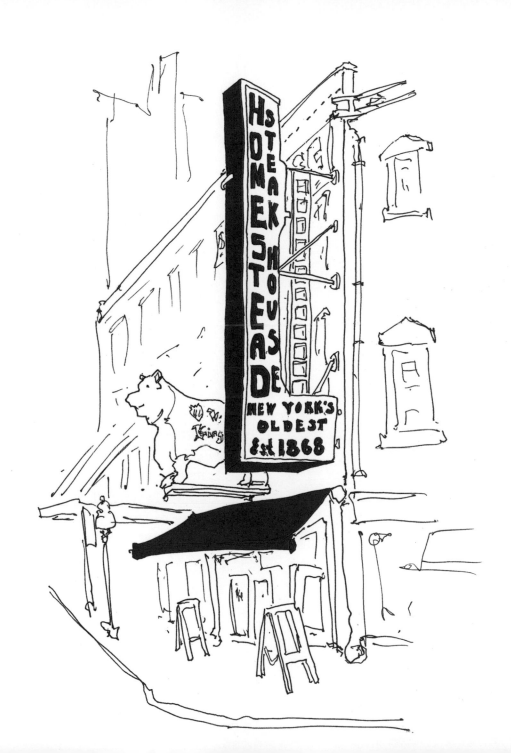

ONE IF BY LAND,
TWO IF BY SEA
17 Barrow St.

Long known as the most
romantic restaurant in the city

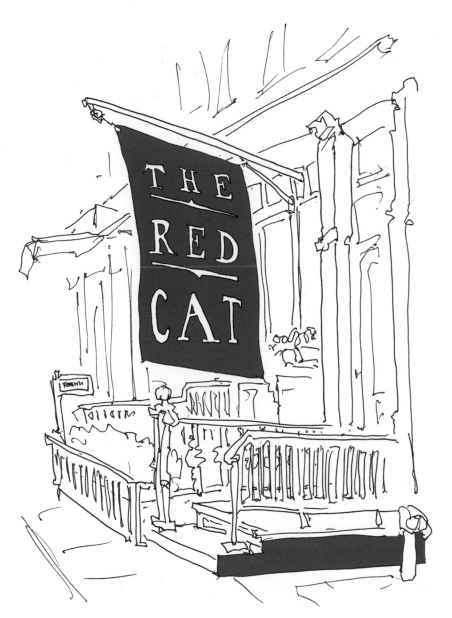

THE RED CAT

227 10th Ave., between
23rd and 24th Sts.
Where you go when you
want a good meal.

TERTULIA

359 6th Ave., at Washington Pl.

(2011–2018)

I get paid to wander the globe in search of deliciousness, have promised myself never to eat at the same place twice, and live in New Hampshire, but this redbrick, worn-wood tapas bar on a corner of Greenwich Village is the neighborhood joint I return to over and again. The air always lingers a bit with manchego, olives, and *jamón Ibérico*. The lighting is dusky, and the chairs are close. Settling in for a good long while is expected. From the first glass of wine—a face-slappingly bold red—I was smitten. Served stemless, a gentle nod to the unpretentiousness of the cuisine that inspired chef Seamus Mullen to open in 2011. It's an attitude that suffuses everything. After the wine, the *tosta matrimonio*, a dish so appropriately named. Thin sheet of toast carrying two splendidly vinegary anchovies—one white, one black—a bit of cheese, a drizzle of balsamic. Intensely delicious. I don't remember the rest of that first meal some six years ago. It didn't matter. I'd be back. Many times. With the childhood friend from whom I'd been separated by two oceans and thirty years: the *huevo diablo*—or smoked deviled egg— seared into my taste memory. With my agent as we haggled a book deal: the *pan con tomate*, bread and tomato evoking simple sophistication. With my son, repeatedly. Watching him evolve from toddler to boy to teen, each step punctuated with *patatas bravas*, fiery, paprika-rich roasted potatoes. Are there better tapas elsewhere in New York City? Or Spain? I don't care. I'll check out those places, of course. But it will be for the food, not the feelings. They might excite my appetite, but they won't satisfy that unspoken—often even unknown—need we all have for a place that is ours.

—J. M. Hirsch, editorial director of Christopher Kimball's *Milk Street* magazine and former national food editor for the Associated Press

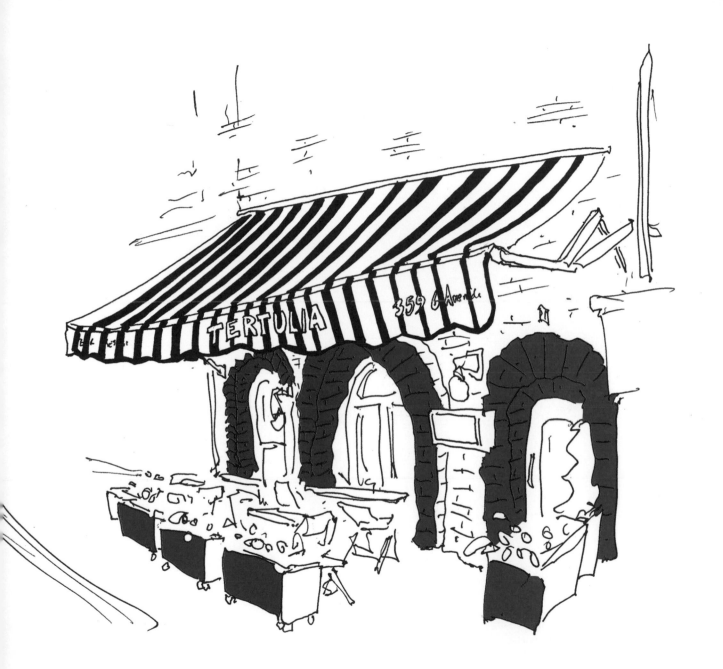

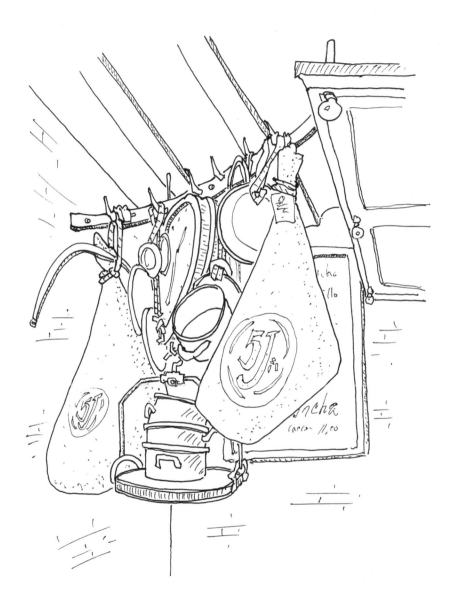

Hams hang over the bar at Tertulia, just like in Spain.

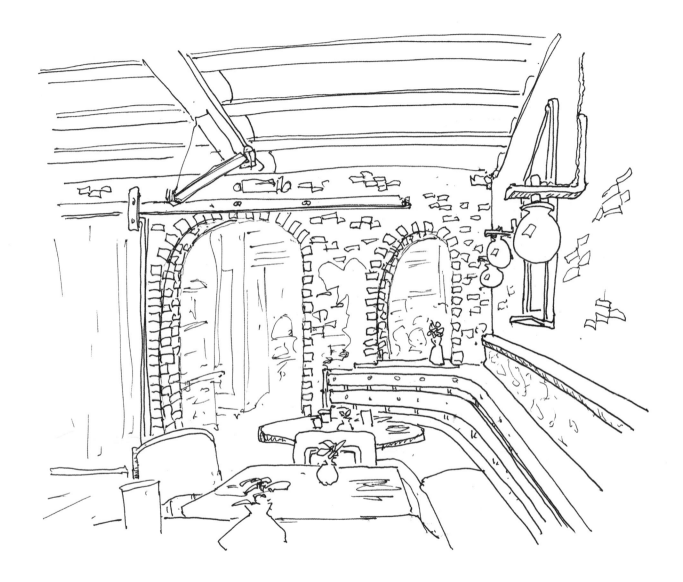

A view from the back room at Tertulia, at a quiet moment

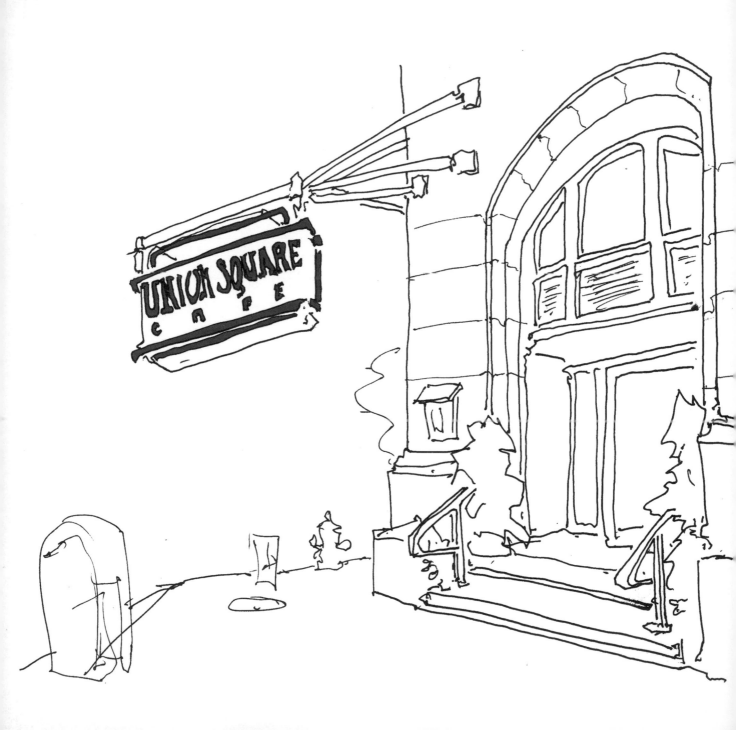

UNION SQUARE CAFE
101 E. 19th St.

The most special meal I had there was with my grandmother, who visited me in New York once a year when her health permitted. I cherish a photo we took at the bar; when I look at it, I notice how the drama of the floral arrangement in the background balances the casualness of the wine bottles and books, placed like personal touches along the wall. It's that juxtaposition of grandness with hominess that makes Union Square Cafe such a special place. Since the restaurant changed locations in 2016, it continues to please and delight, and perhaps there's even an added element of intimacy to be able to say, "I knew Union Square Cafe when . . ."
—Kate Sangervasi

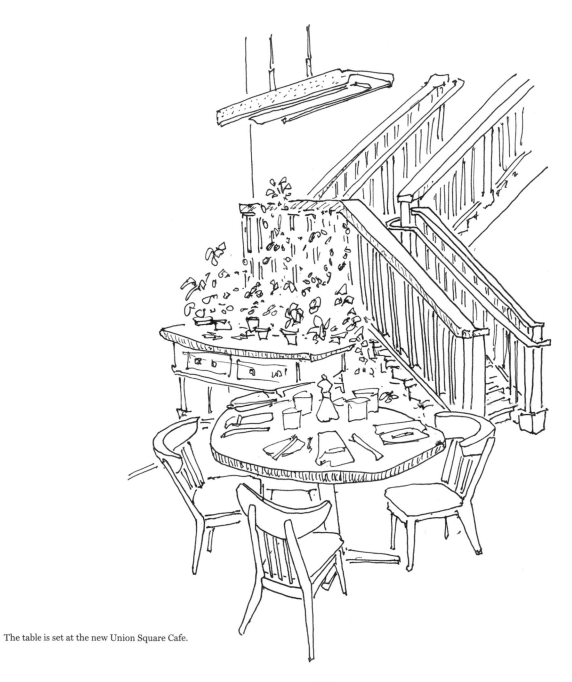

The table is set at the new Union Square Cafe.

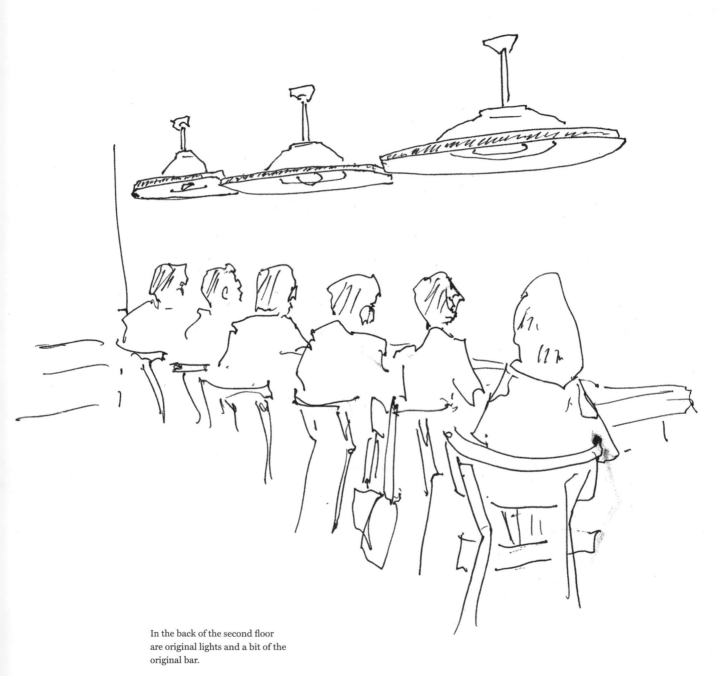

In the back of the second floor
are original lights and a bit of the
original bar.

MANHATTAN

EAST VILLAGE

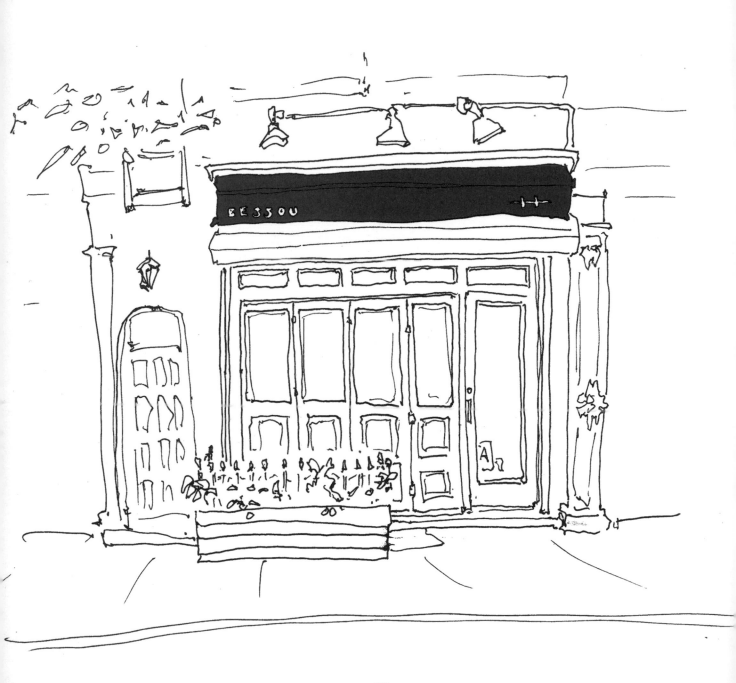

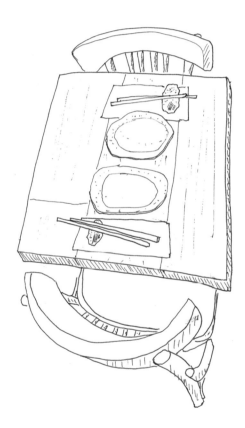

The tables at Bessou are cozy and chic in that way that only Japanese design can accomplish.

BESSOU
5 Bleecker St.

The name Bessou is Japanese for "second home." When I decided to open a restaurant, the word really captured what I wanted the restaurant to be for others: a neighborhood place, like going to your local home away from home. In fact, this space before we moved in was called Bianca and was my go-to local spot for many years. I both celebrated special occasions and enjoyed countless weeknight dinners there. Whether or not it was fate that brought me to the location, I'm fortunate to be given a chance to continue to offer it as a second home to others in the form of Bessou.
—Maiko Kyogoku, who opened Bessou in 2016

GREAT JONES CAFE

54 Great Jones St.
(1983–2018)

I was the first waitress of the Great Jones Cafe,
or the Jones, as it is still affectionately known.
It was June 1983. My friends Phil Hartman and
Rich Kresberg were the new owners, and with all
the preparation for the opening—construction,
decorating, figuring out the menu, hiring the chef,
bartender, and dishwasher, they had not thought
about the waitstaff. I had been hanging around
helping with the setting up.

"How about me?" I asked.

"You're hired," Rich and Phil said without
hesitation.

We toasted my new job with Cajun marti-
nis—vodka infused with jalapeño peppers. We
were experimenting with various recipes of the
signature cocktail. With only eleven tables they
figured one waitress could handle the floor. That
was fine for the first couple of weeks, but then
the word got out: The Great Jones is *the* spot—a
little bit of New Orleans in New York. Jambalaya,
étouffée, oyster po'boys! Good food and a jukebox
filled with Dr. John, the Neville Brothers, and the
Meters. It got very busy, very quickly. Soon more
waitstaff came on board and the Jones family
grew. We ate, drank, and danced (often on the ta-
bles) with patrons, many of whom hung out until
the wee hours. It was one of the best restaurant
gigs I ever had. At the end of a shift, I was tired on
my feet, but the pockets of my apron were filled
with tips.

—Emily Rubin

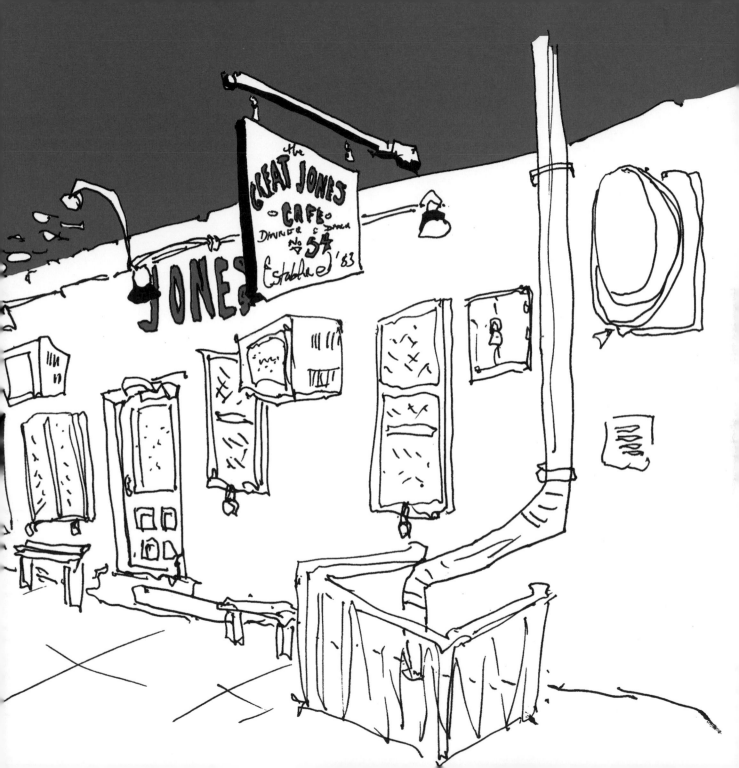

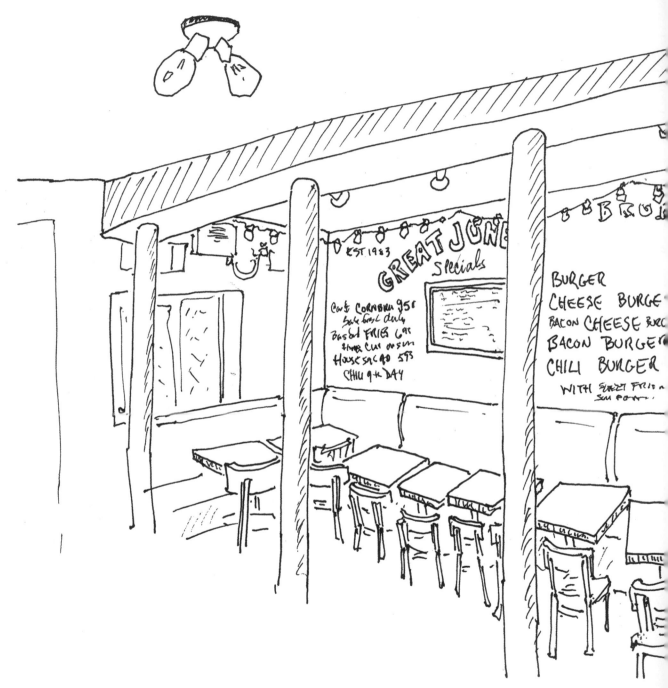

The kids that might have resulted following a night of fun in the early days of the Great Jones Cafe would be old enough to have kids of their own by now, but word is they're still dancing on the tables there.

IL BUCO
47 Bond St.

The day I moved into my apartment above the restaurant, I went down and introduced myself to the bartender. A woman sitting at the bar said, "So, you're the guy." I had no idea what she was talking about, but it turned out there had been an article in the *New York Observer* that mentioned the sale of the apartment, since the guy I bought it from was a reasonably well-known interior designer. The restaurant started out as an antiques store that eventually sold cheese and wine to patrons and then meals, and then they probably realized they couldn't lose a dining room table just before a sitting, so they stopped selling the furniture. I can't tell you how many times I've eaten there in the past eighteen years. And the people I've seen, even though I know this is New York, continue to amaze me. But the most important person to eat at il Buco is Lauren. I had my first date there with her, and it's where I proposed to her. We still live above it, and we have a three-year-old daughter. Everyone in the restaurant knows her.
—Justin Woodis

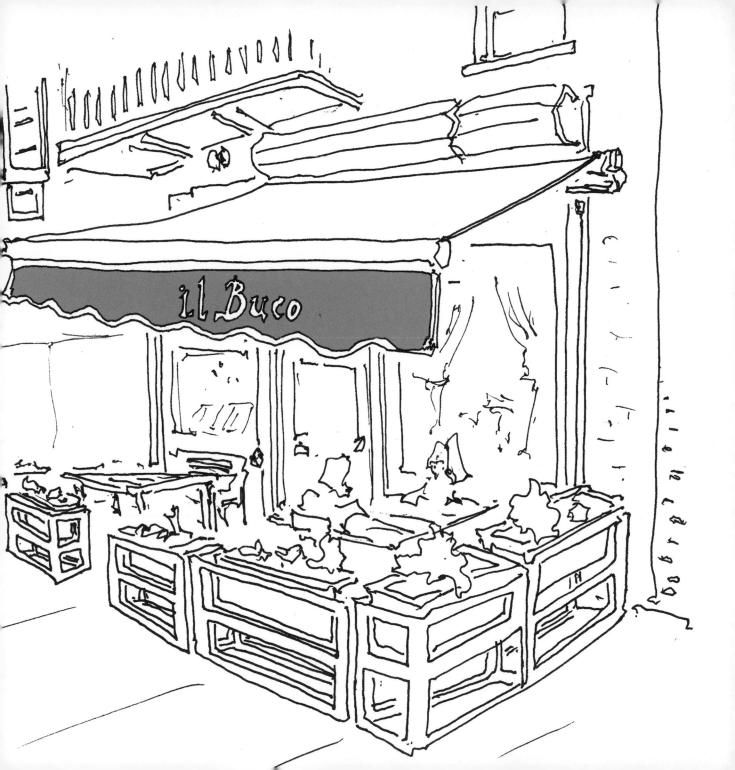

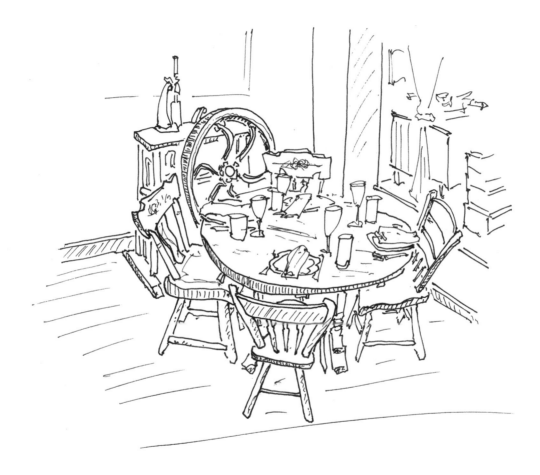

What started out as an antiques store has turned
into one of the city's favorite dining spots.

According to legend, the wine cellar inspired
Edgar Allan Poe's "The Cask of Amontillado."

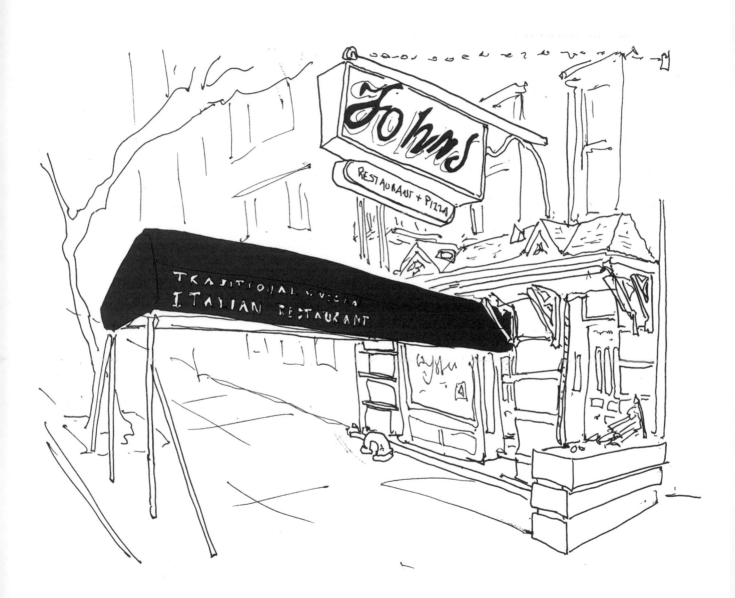

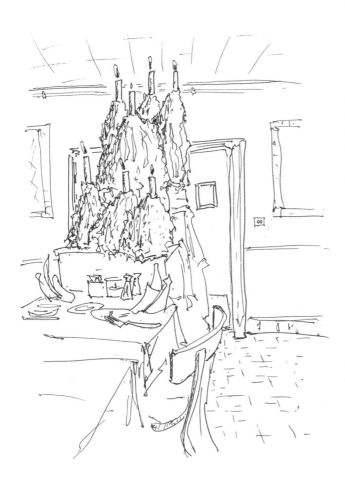

The two-hundred-plus-pound candle mountain
is a fixture of the back room at John's.

JOHN'S OF 12TH STREET
302 E. 12th St.

During Prohibition, Mama John, the wife of the
founder, John Pucciatti, had a still in the base-
ment. To stay clear of law enforcement, they put
a candle in the front window. If the police were
on the block or nearby in the neighborhood,
they would blow out the candle and the patrons
would quickly drink up. With the repeal of the
Eighteenth Amendment in 1933, the candle
took on new meaning. They lit it in celebra-
tion of the end of Prohibition, and it has been
burning ever since. It's now in the back room
and weighs more than two hundred pounds
and requires regular maintenance. We can't let
it get too near the ceiling, so we shave it down
when that happens. But it's not going away. It's
as much a part of John's as the original tile floor
that was laid in 1908.
—Lowell Fein, one of the current owners of
John's. (There have been only three proprietors
in its hundred-plus-year history, but to think of
it solely as an old-school meatball haven is to be
mistaken—John's has a vegan menu, too.)

LUCIEN

14 1st Ave., at 1st St.
Twenty-plus years of
comforting French fare

MOMOFUKU
NOODLE BAR

171 1st Ave., between
10th and 11th Sts.
The first settlement in
chef David Chang's
revolutionary empire

PRUNE

54 E. 1st St.

A consistent reminder that
some very good things came
out of the 1990s.

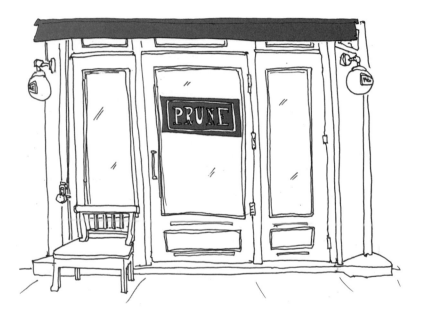

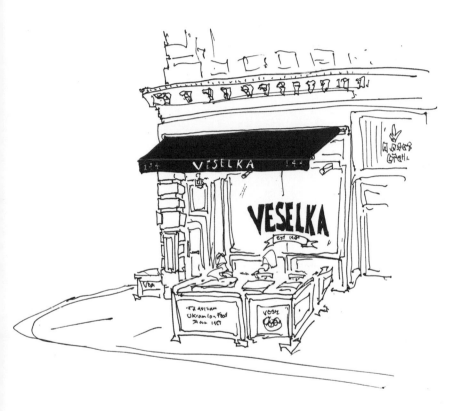

VESELKA

144 2nd Ave., at 9th St.
The name means "rainbow"
in Ukrainian, and pierogis,
borscht, and other old-world
comfort foods are the pot of gold
at its end.

MANHATTAN
SOHO
AND NOLITA

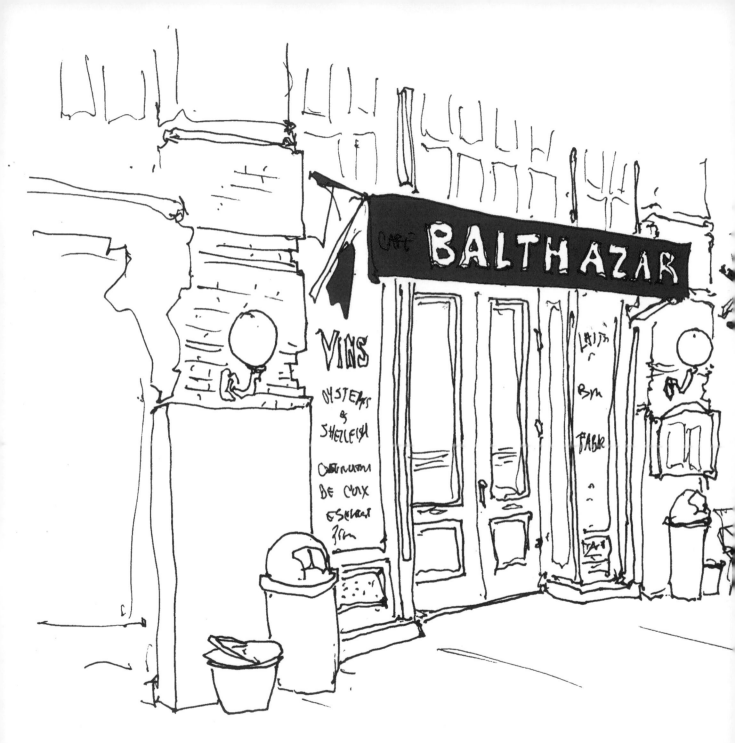

BALTHAZAR

80 Spring St.
The Soho institution
and Keith McNally's pièce
de résistance

BLUE RIBBON BRASSERIE

97 Sullivan St.
Long a late-night spot for
chefs, it's still quite pleasant
at more humane hours.

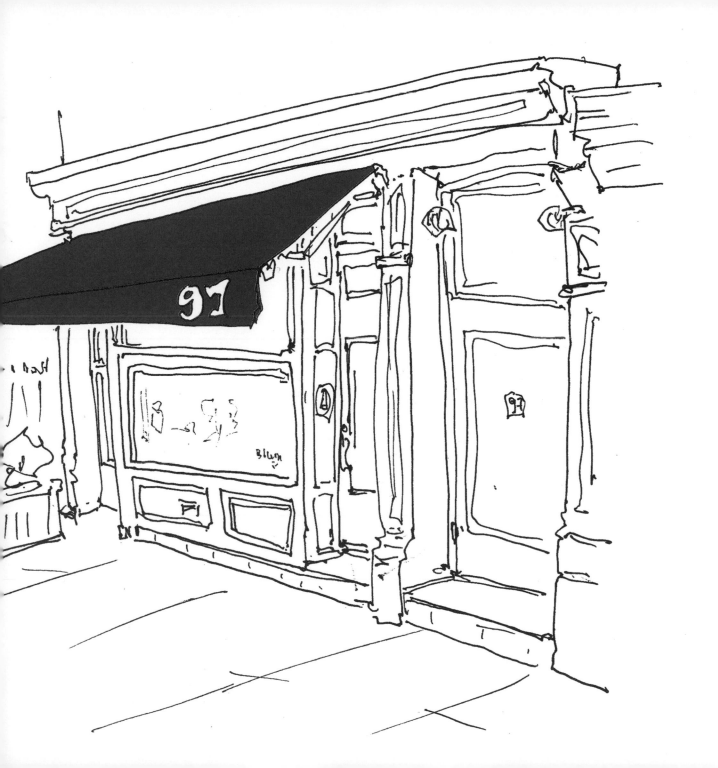

THE DUTCH
131 Sullivan St.

A few years ago, after a stint in New York, I was living with my husband and two young children in Westchester. I had grown up there, but the return was not what I had expected. My younger son had serious medical issues, and I needed to pause and reassess things. We ended up moving back to the Upper West Side. Still, for the next two years, we were running to doctors' offices for my younger son and hockey practice for my older one, and between everything else my husband and I basically ended up being strangers to each other. So we decided to go on a date. We hadn't been on a date in years, so we thought it would be a good idea to have a ground rule—no talking about the children. We picked the Dutch because the brother of a close friend was Jason Hua, the executive chef there. We'd met before. On a ski trip to Vermont with my friend and her family, he basically cooked for us the entire week. He made kimchi rice. There's nothing better on a cold day than kimchi rice. My mom used to make it when I was a kid. To keep things light and spontaneous on our date, we didn't make a reservation and we didn't tell Jason. We wanted to see him, but we didn't want him to make a big deal about it. My husband took the day off from work and we went to lunch. But it turned out to be Jason's day off, too. It was so awkward. Without the

kids to talk about, we had nothing to say to each other. It was horrible. But then the food arrived. As soon as I had a bite of my hanger steak and kimchi rice, and my husband started his lunch, the ice melted. We talked about everything we had been through over the past few years, and by the time we left, we were laughing.
—Christina Chu

The Dutch is a large and rambling space that's warm and welcoming throughout.

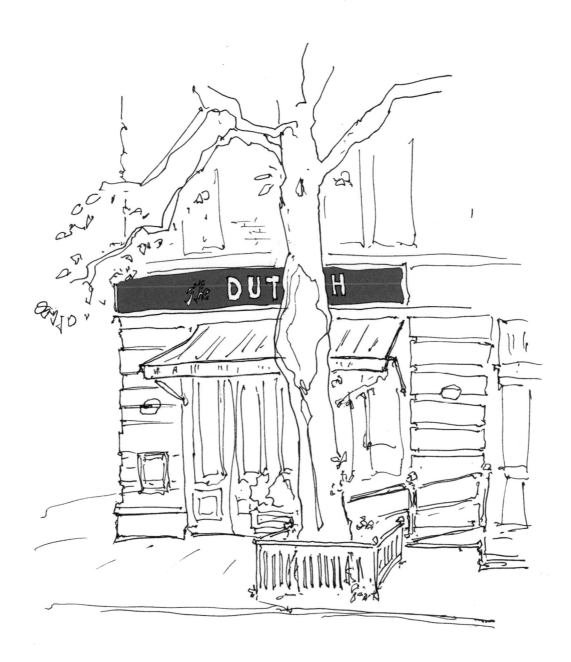

LA ESQUINA

114 Kenmare St.

Look for the hidden door and
act like you belong.

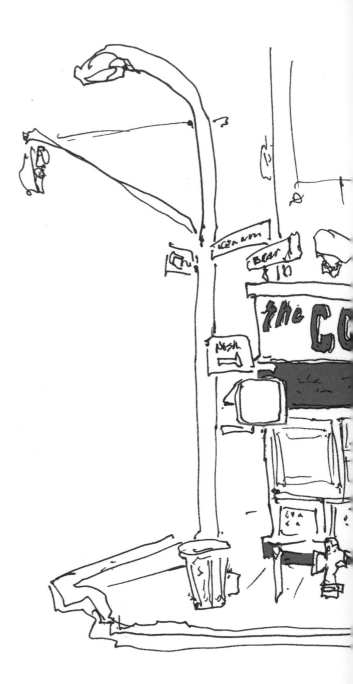

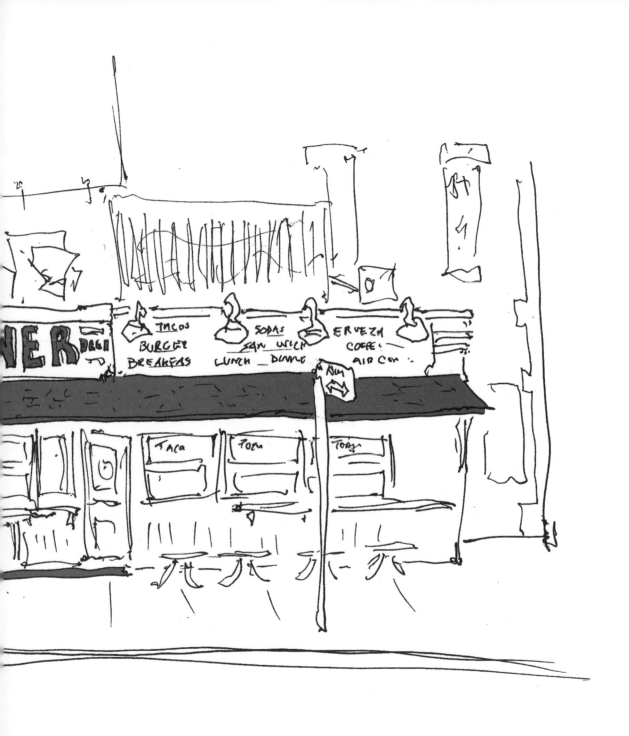

LOMBARDI'S

32 Spring St.

No slices but a lot of history, with a lineage to the nation's first pizzeria

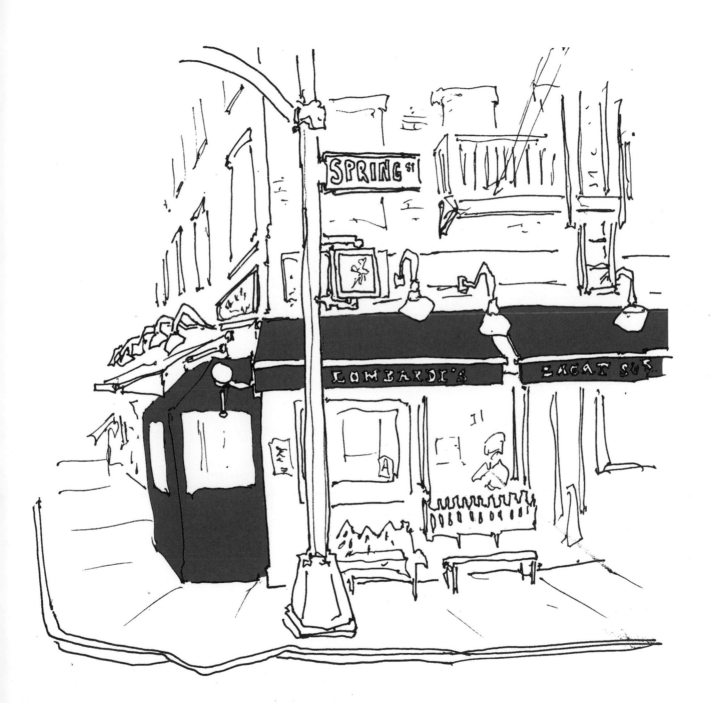

PEASANT

194 Elizabeth St.

Frankie built the oven, rotisserie, and grill by hand. He never had any cement or masonry experience, but he figured it out. He used bricks from the demolition of the space. There was a small problem, though—he ran out of bricks. It was fortuitous that Nolita was going through a renovation period back then, and every other building had a huge dumpster in front of it. Frankie and his sidekick, Chickie (our dishwasher), went out around the neighborhood, dumpster-diving for vintage bricks. At first it was a covert operation only attempted at night, but the contractors were more than happy to get rid of them. So the ovens are part of the original neighborhood, a reminder of what Little Italy was made of. A funny story involving the ovens happened a few months after September 11. It was a crazy time when most people were barely over the shock but wanted to go out and see people and try to pretend that life was the same. One Saturday night it was really busy, with VIPs all over, and a good friend, Hal Rubenstein, was at a table with Calvin Klein. All of a sudden, smoke started filling the room. We assumed it was a downdraft and we opened the front door and checked the ventilation system. The smoke kept coming. We looked up, and our kitchen ceiling is glass, so we could see the vent pipe was on fire—not a good thing. We shut down the ovens, called the fire department, and told customers that their dinner was on us but they had to get out. But no one left. Then we started yelling that the kitchen was on fire, it was dangerous, get the hell out. Nothing. Apparently, the PTSD New Yorkers were suffering from made them completely immobile. Everyone kept on eating and drinking. Waiters were scrambling; customers were signaling for more wine. "No more wine!" I screamed. I ran to Hal's table, where he and Calvin were eating their roasted game hens. I told them the situation and Calvin replied, "It's just a little smoke, dear." I was dumbfounded. We were all going to burn together. This was it. The end of Peasant, the end of our dream, the end of these poor, crazy people! Luckily, the fire department arrived. We heard cheers and whistles. Everyone was on their feet, and I thought to myself, "Great, the customers are finally leaving." But no, the guests wanted to applaud New York's bravest. This wasn't an effort to flee a fire—it was a standing ovation. It was an amazing moment. Within minutes, the small fire was put out; it turned out to be a fault in the vent and no big deal. We didn't even have to close. Nothing comes between New Yorkers and their dinner.
—Dulcinea Benson, who married Frank DeCarlo and signed a lease at 194 Elizabeth Street in the same week in 1999.

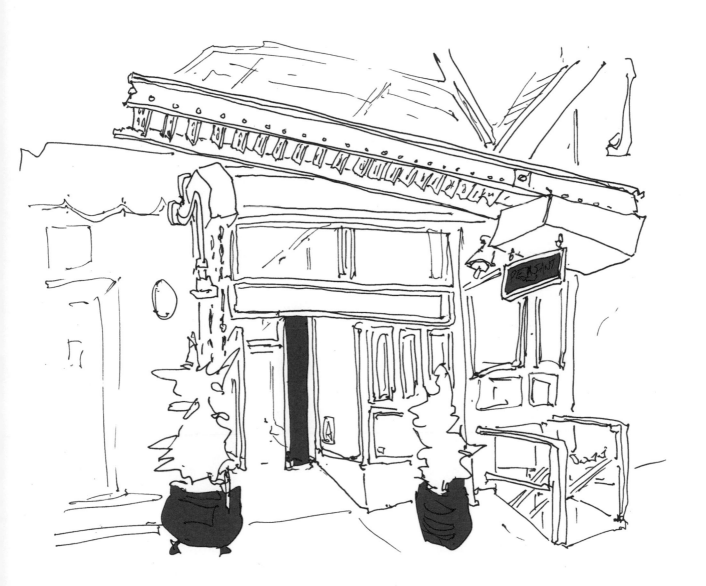

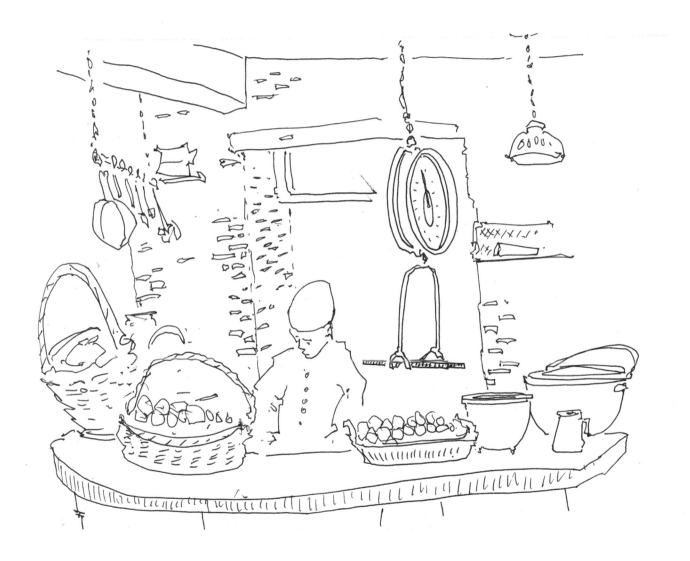

Early in the evening at Peasant,
a chef prepares for the night's covers.

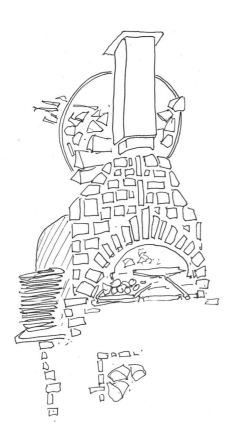

Built by hand, the ovens at Peasant
handle the dinner rush with ease.

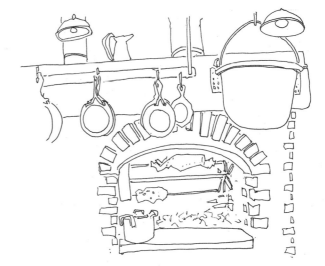

There are few places more warm and
welcoming than the kitchen at Peasant.

RAOUL'S
180 Prince St.
Steak au poivre that will
make you feel like a star

TACOMBI

267 Elizabeth St.

The night Hurricane Sandy hit, my girlfriend, who later became my wife, Kasey, and I were in our tiny studio apartment in the East Village. We saw a flash of light and heard a boom. We thought it was lightning, but it was the Four-teenth Street Con Edison plant over by the East River exploding. The power went out in Man-hattan below Thirty-Ninth Street, and I started to think about Tacombi, where I was working at the time as director of operations. The next day, it was like the Wild West down there as I biked to Nolita. People were just lost and confused without access to news and information. I waited in line an hour to use a pay phone, and while I was on the phone, someone tried to steal my bike, which was leaning on the phone I was on. We had a restaurant full of food that would go bad unless it was eaten. Somehow, at Ta-combi the gas was still on, so we started giving away food. We wanted to take care of people. The power was out for a few days; still we did everything we could to keep the staff on payroll. At one point a neighbor had a generator, but people complained that it made too much noise and we couldn't use it. We served tacos and rice and beans by candlelight while rumors about the power's return swirled around. Then the lights just came back on, and that was it. We were right back at it.
—Nathan Siegel, who served as Tacombi's director of operations from 2012 to 2015

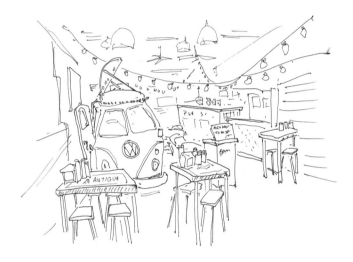

A VW bus greets diners inside Tacombi for that back-to-the-playa feeling.

LOWER EAST SIDE

MANHATTAN

DIRT CANDY
86 Allen St., between Grand and Broome Sts.
Amanda Cohen's podium for changing the world's view of vegetable cookery, one tasting menu at a time.

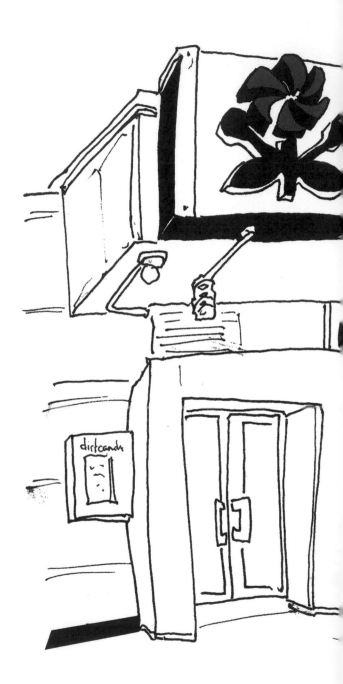

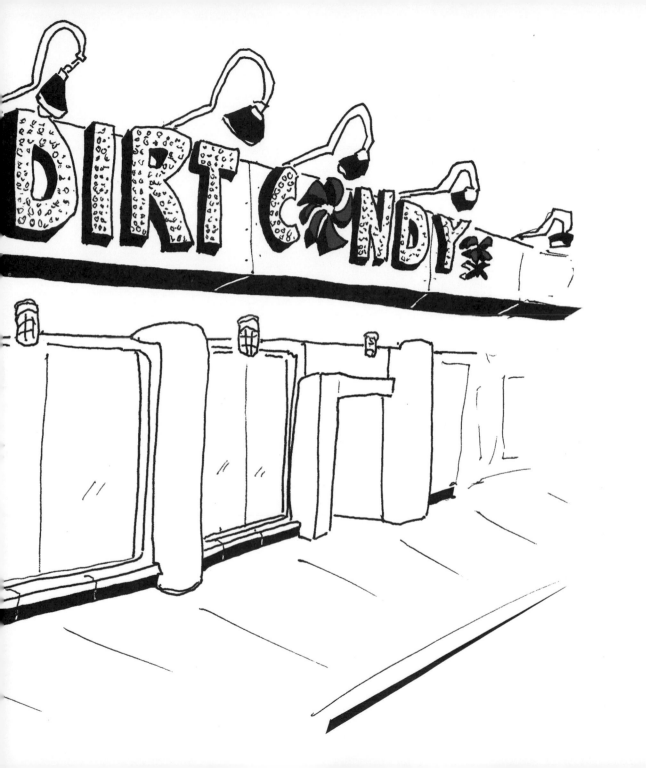

KATZ'S DELICATESSEN

205 E. Houston St., at Ludlow St.

Two guys are always stationed by the door at Katz's, just inside the entrance. One of them is usually standing, the other hunched over in a folding chair right next to an old-fashioned ticket dispenser. This ticket is one of Katz's famous quirks, the meal ticket these guys hand to every person who walks in, and every time they say it right to your face: "Don't lose the ticket." They'll ask if you've ever been there before, and if not, they'll explain—don't lose the ticket; show it to every counterman you go to; lose it and you'll pay the penalty (it's fifty bucks). I have seen a grown woman sobbing, in tears because she lost her ticket. You come in, you get your ticket, the counterman writes your running tab on it, and on the way out, right there by the same door, you hand over your ticket to the cashier and pay your bill (in cash, unless you know the secret credit card counter). Mine was such a Katz's family that when my parents lived outside the city, in Japan, Atlanta, wherever, my grandmother, whose apartment was in Inwood, would make the trek to Katz's to buy a large hard salami to bring them as a gift when she went to visit them. Katz's is like a circus when you're there. It can be so busy and colorful and so New York. There are times, though, when it's quiet, which is when I go, weeknights after eight. Pastrami on rye with mustard and one sour pickle, every

time. Speaking of circuses, my family has always loved the actual Ringling Bros. and Barnum & Bailey Circus, and a few years ago we got to see what turned out to be its final tour. My wife and two teen boys drove from our Harlem neighborhood to Brooklyn's Barclays Center for the show. When we were headed back home that Sunday night, down Flatbush, over the Manhattan Bridge, everyone was hungry and whiny and grumbling for something to eat. All of a sudden, when we were on Houston Street heading toward the FDR, my Katz's light bulb went off. The parking gods smiled on us and we pulled over. Sunday night's one of those perfect times to go to Katz's, when it's quiet and there's no line. It was my boys' first time. They had franks. I split my usual pastrami sandwich with my wife. And my kids became fourth-generation Katz's enthusiasts, for life, I hope.
—Mark Satlof

I asked the counterman at Katz's if they used this often. "Every single day," he said.

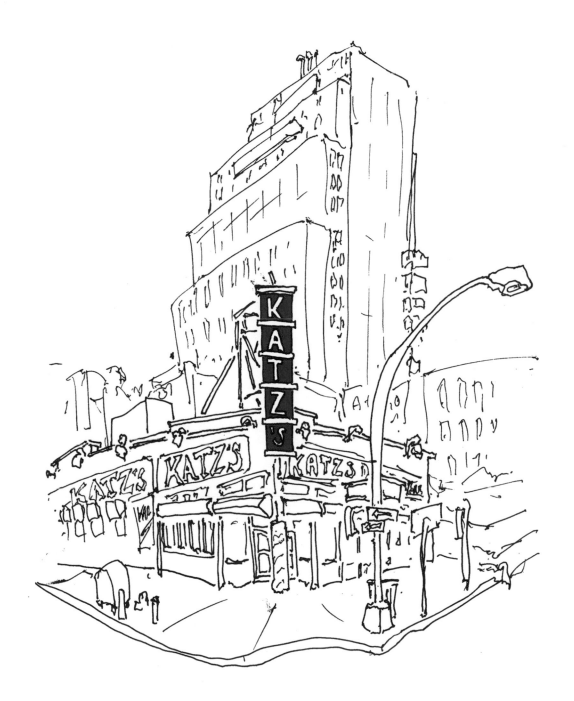

MISSION CHINESE

171 E. Broadway

Szechuan hallucinations

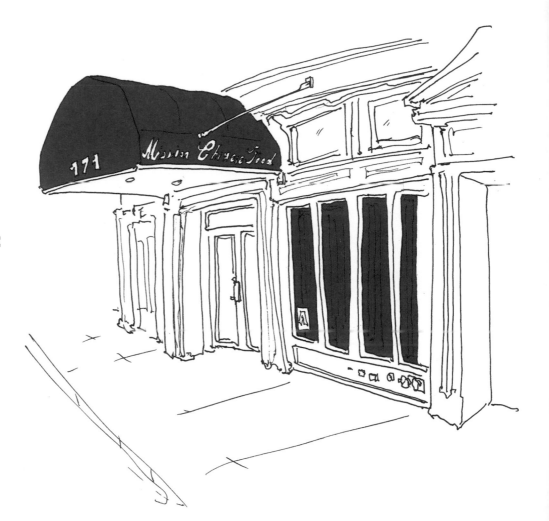

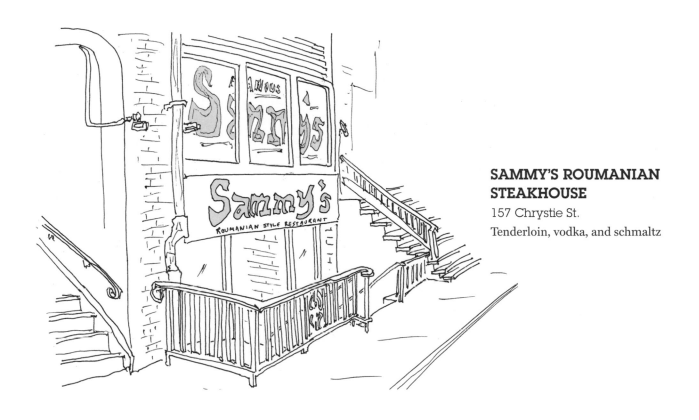

SAMMY'S ROUMANIAN STEAKHOUSE

157 Chrystie St.

Tenderloin, vodka, and schmaltz

UNCLE BOONS

7 Spring St.
Not your father's subterranean
Thai restaurant

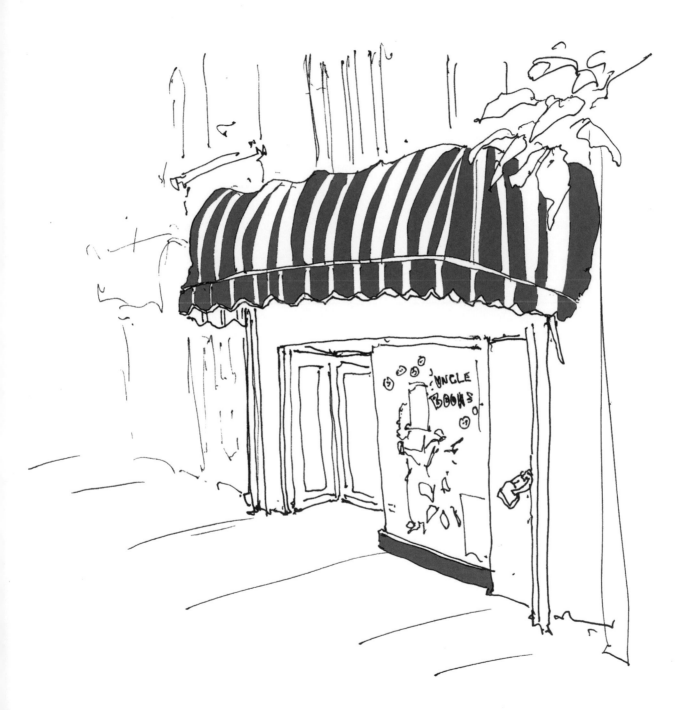

YONAH SCHIMMEL
KNISH BAKERY

137 E. Houston St., between Forsyth
and Eldridge Sts.

I first went to Yonah Schimmel in early 2002, a few months after 9/11. It was my first trip to New York and I immediately fell completely in love with the entire city, but especially the Lower East Side. Yonah Schimmel represented everything I had read about the Lower East Side—the whole building is literally lopsided, the service is at best rudimentary, and I had no idea what the hell a knish was. (Not much Jewish cuisine in the working-class suburbs of Australia, where I grew up.) I was infatuated with the place, its history, and I ate there every day, even though my hotel was in midtown. After that, every time I came to New York I would do two things the first day I was in the city—I would walk over the Brooklyn Bridge and I would eat a knish at Yonah Schimmel. Then, in 2006, I taught a university summer program in New York and lived on Essex Street with my wife and our two children. I ate at Yonah Schimmel almost every day. Often during that summer, I would sit in the knishery, looking out at East Houston Street and fantasizing about living and working in New York. Through a miraculous set of circumstances, my dream came true and I got to move to New York with my family in 2011. I still eat at Yonah's whenever I can, and I have been known to get off the F train on my commute to pick up a knish or two before heading home to Brooklyn. For me, Yonah Schimmel is a sort of emotional core of my New York experience.

—Simon Adams

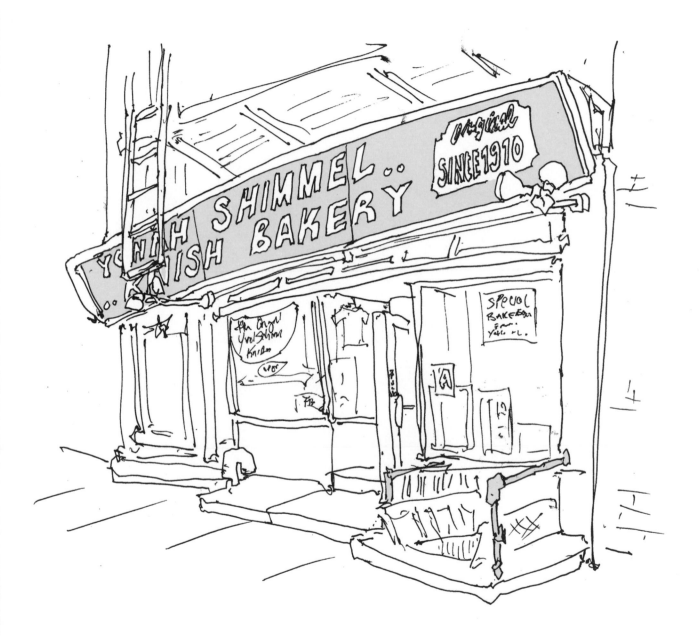

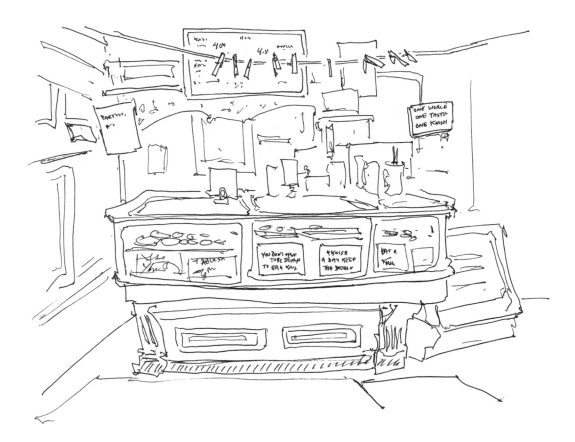

The front counter at Yonah Schimmel

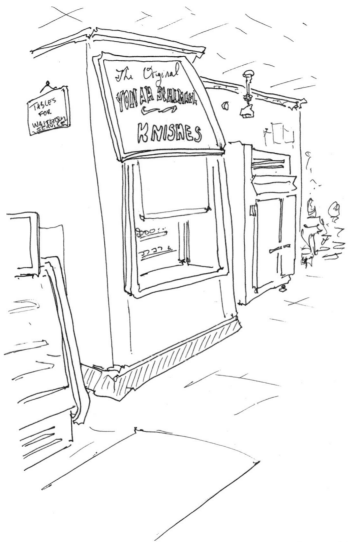

The original dumbwaiter brings fresh delights to hungry customers.

BRUSHSTROKE

30 Hudson St., at Duane St.
The semisecret sushi bar inside
David Bouley's take on kaiseki
has been replaced by a surpris-
ingly affordable, no-reservations
noodle bar.

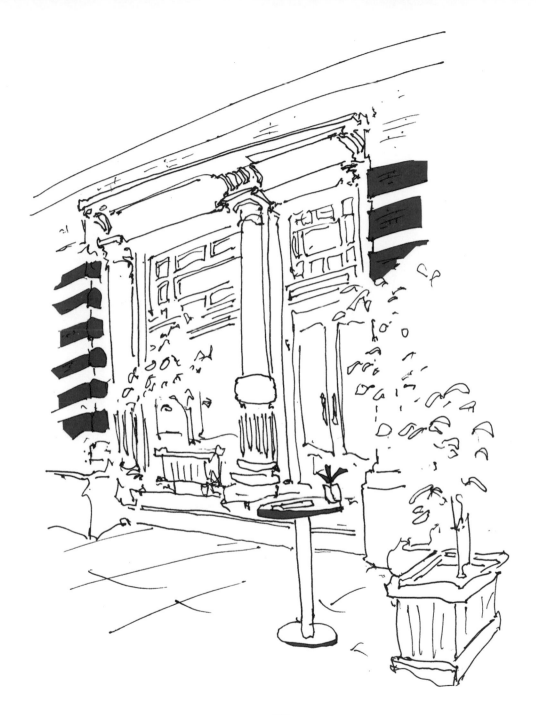

BUBBY'S

120 Hudson St., at N. Moore St.

In 1990 I was flipping eggs at Florent, the since-closed Meatpacking District hangout, and working on being a writer. When I was trying to write, I had the habit of going to the grocery store and buying all kinds of silly food— Pillsbury Poppin' Fresh Dough, sardines, Oreos. One day I saw that Pillsbury was sponsoring a pie-baking contest. The prize was $25,000, which I could have lived off for a long time back then. I taught myself to bake, practicing on the job at Florent. I never did win the prize, but I went into the wholesale business. I had a creative arrangement with my Tribeca land-lord. Remember, back then there was nothing down here. He would let me make pies so long as I didn't sell them to the public. But it wasn't like it was a secret. The whole neighborhood smelled of pies. Everyone kept asking me about them. Finally, he let me open up. For one day. I picked Thanksgiving, of course. We had a big meal that night and got drunk and decided to stay open. This was easy because my landlord was out of town at the time. We had a three-week run until he walked in during the middle of a lunch service and demanded to know what was going on. We worked things out and the business just grew. Babies have had their first solid food here, and I fed my own mother many meals here. John Kennedy ate his last breakfast

at Bubby's. Spalding Grey, too. Eliot Spitzer was in when his career was imploding. Every-one is welcome. Jeremiah Tower said he wanted theater at his restaurants. People like Sirio Maccioni wanted theater at Le Cirque. I want whoever went to Le Cirque last night to come to breakfast at Bubby's the next day, in their pajamas.
—Ron Silver, the owner of Bubby's, which has two locations in Manhattan and a few in Japan

At Bubby's, it all started with pies.

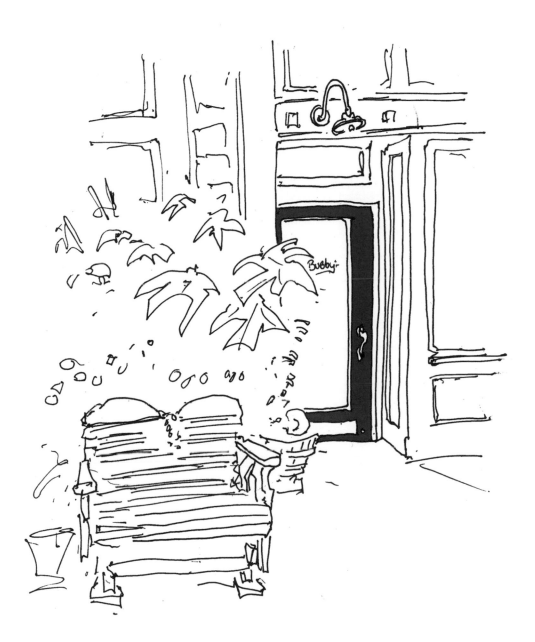

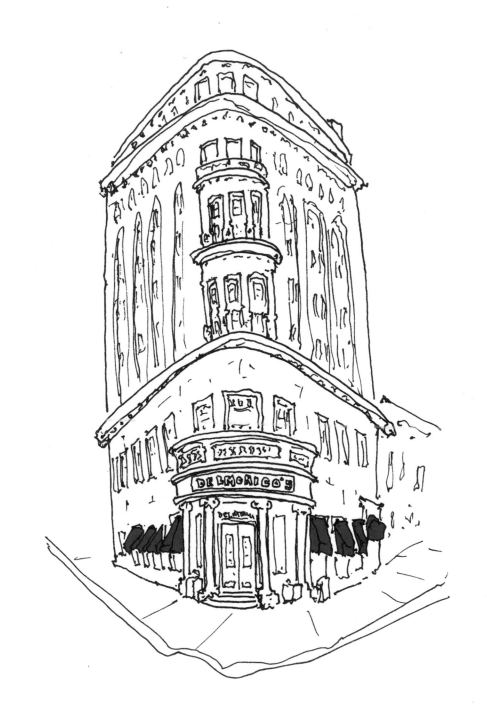

DELMONICO'S RESTAURANT

56 Beaver St.

They say the columns on the facade
were salvaged from the ruins of Pompeii,
and that Baked Alaska, eggs Benedict,
and lobster Newburg originated in
the kitchen.

FRAUNCES TAVERN

54 Pearl St.
Not only is it where George
Washington ate, but it's also
home to a fragment of his den-
tures, in the museum upstairs.

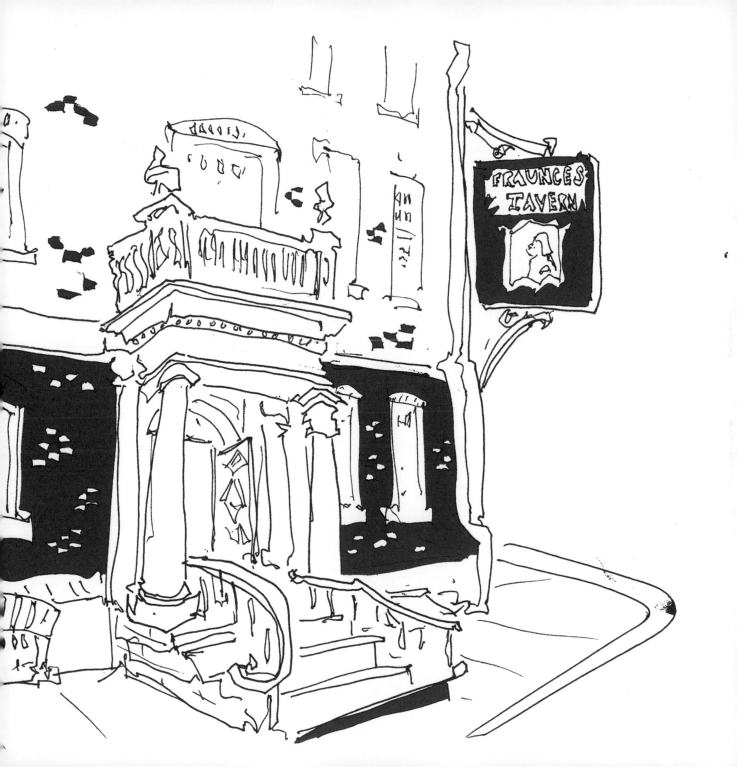

LOCANDA VERDE
377 Greenwich St.,
at N. Moore St.
Fine Italian food from
Andrew Carmellini

NOM WAH TEA PARLOR

13 Doyers St.
The oldest dumpling house
in Chinatown

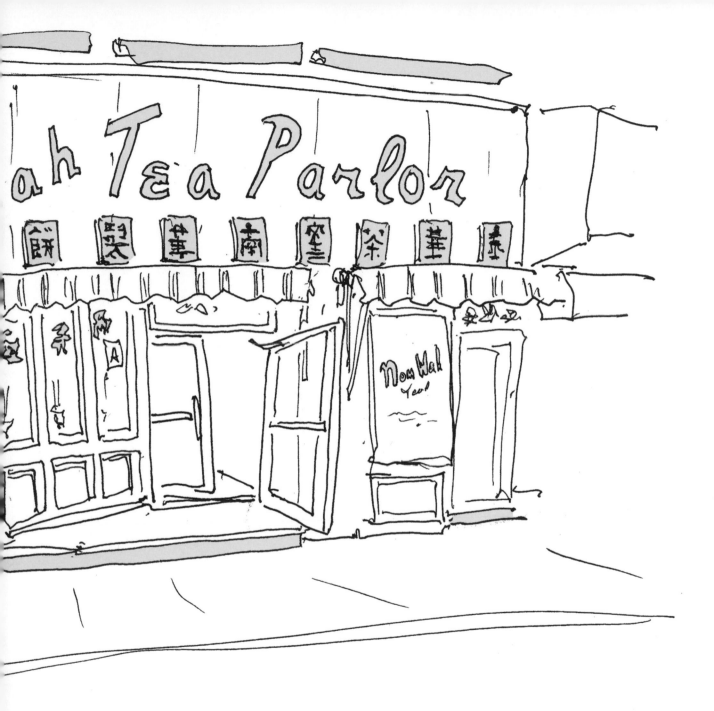

THE ODEON

145 W. Broadway, at Thomas St.

A long time ago I was living in New York and trying to make it as an art director and artist. One Saturday afternoon my friend Sandy, who had a friend who owned a gallery in Soho, was supposed to come by my Tribeca loft to look at a few of my paintings, so she could connect me with her gallery-owning friend. Before she was due to arrive, I put a can of minestrone soup on the stove on a low flame, so it would be ready to eat after she was done. Sandy ended up arriving an hour late, and that changed everything. My soup was burnt and dried out in the bottom of the pot, but Sandy redeemed herself by bringing along a cute, curly-haired blonde named Nancy in a bright orange coat. Nancy and I hit it off like we'd known each other for years. Within five minutes of showing them my work, I quickly recalibrated and decided that Sandy getting me into the gallery was a distant second to Sandy getting me Nancy's number. When we finished our loop around my loft/makeshift gallery, I didn't want our conversation to end. As I glanced at what was supposed to be my meal on the stove, I casually tossed out, "Hey, guys, let's go for lunch. The Odeon is just up the block from here." The Odeon has always managed to pull off being cool without being pretentious, a delicate balance not often found among the eateries in the Triangle Below Canal, and I was hoping it would go over well with Nancy, a Jersey girl who herself was cool, but not pretentious. I'm not sure what that Jersey girl thought of the Odeon that day, but its glowing red neon letters drew us in and we bonded over discussions of art and life. As Sandy, who had a front-row seat to it all, put it: "It was as if the rest of the world disappeared around you and you were the only two on the planet." I couldn't tell you what I ate that afternoon or if the service was good; all I know is I left with the person who'd wind up being my wife and still is twenty years later.

—Matt Vescovo

The grand art deco bar commandeers one side of the Odeon.

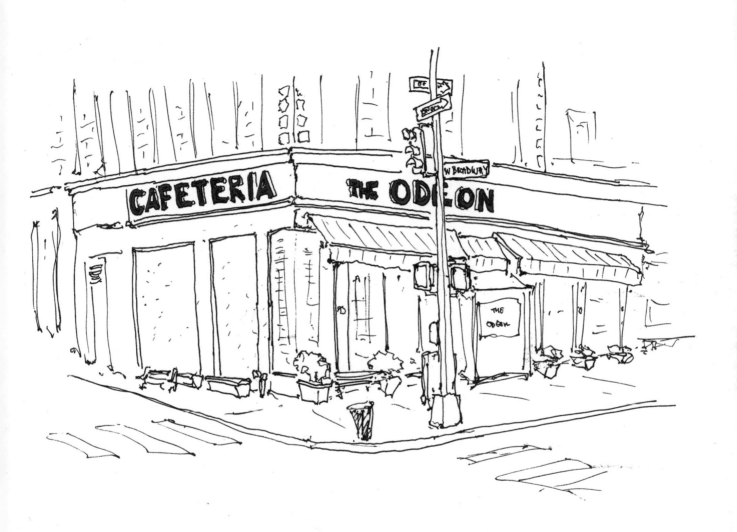

BROOKLYN

DOWNTOWN TO PARK SLOPE

AND BEYOND

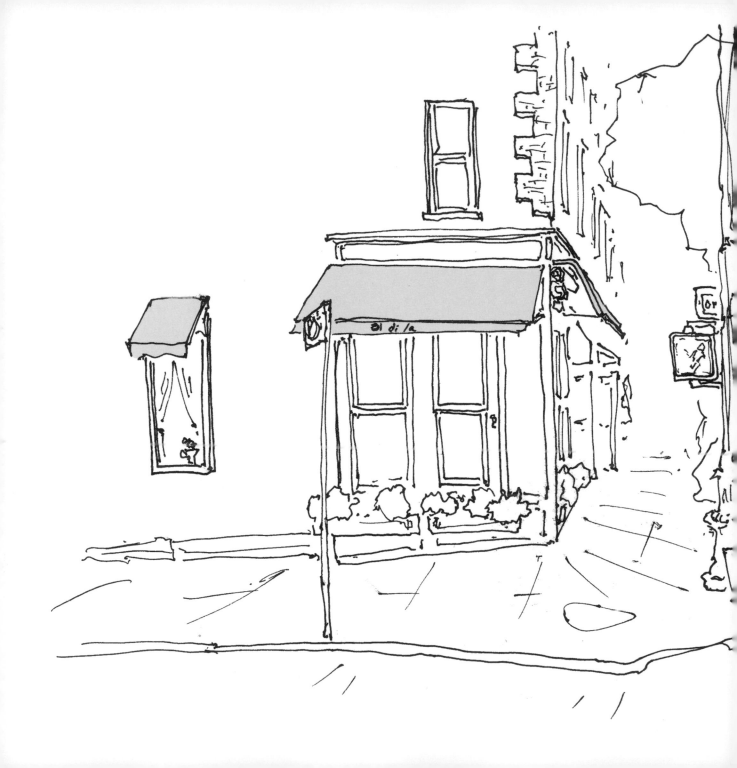

AL DI LA
248 5th Ave., at Carroll St.

I met Anna in Verona, where I was running
a cooking school when she came as a visiting
chef. The class was one week, but she spent a
year in Italy before returning to New York, to
work at Union Square Cafe and then at Lespi-
nasse. Eventually I followed her and found a
job restoring antiques in Soho, and we moved
in together in Park Slope. Two years later we
opened Al Di La, and our dream to follow our
passion for food and to find an opportunity to
work together became a reality. Anna had the
skill and I had the memories, and it is how
the menu came together: tripe from the market
in Florence, *casunziei* ravioli from a skiing
vacation in the Alps, *malfatti* from the cooking
lesson on the hills of Tuscany. It has been
twenty years and we still run our trattoria in
Brooklyn together.
—Emiliano Coppa, the host of Al Di La, which
he owns with Anna Klinger

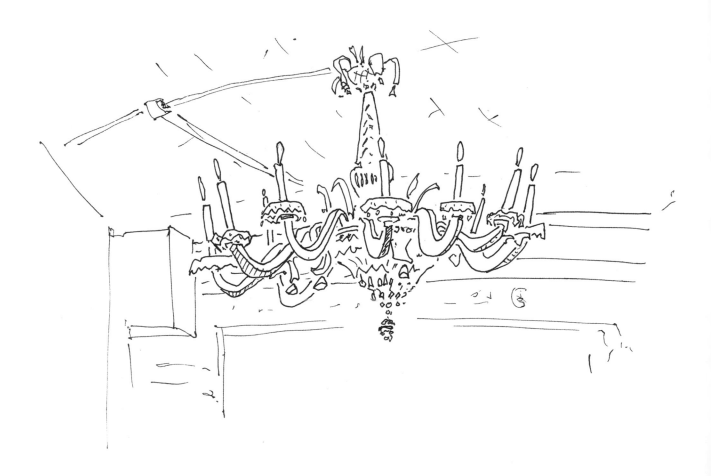

These are the chandeliers in the main dining room.

DI FARA PIZZA
1424 Ave. J

Domenico DeMarco emigrated
from Italy to fulfill his destiny
by making pies here, which he's
done since 1965, using the finest
ingredients from his homeland
and cutting the basil with scis-
sors. Just be prepared to wait.

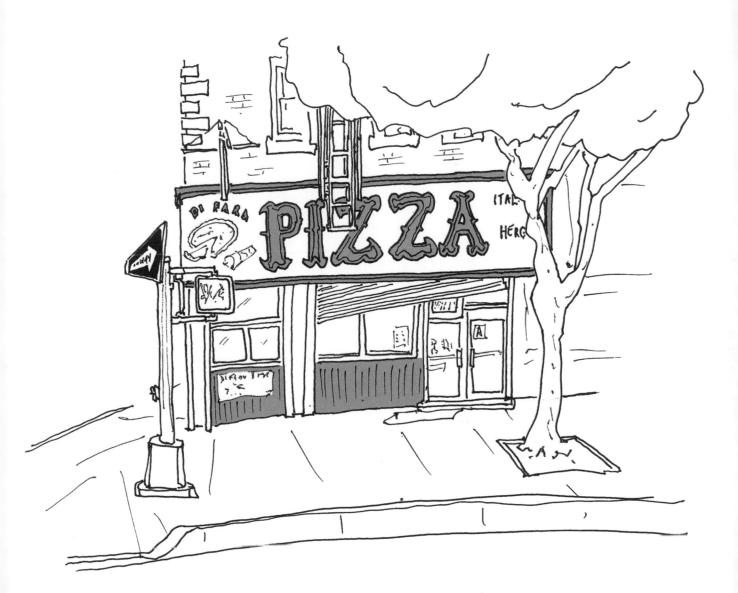

FONDA

434 7th Ave.

In 2009, a delightful twist of fate brought Roberto Santibañez, one of Mexico City's most acclaimed chefs, to Park Slope. To judge by the locals' devotion to the margaritas at happy hour, he's not going to want to pull up stakes anytime soon.

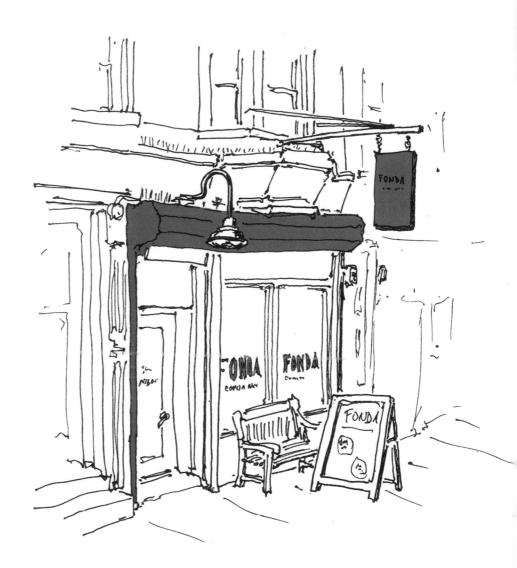

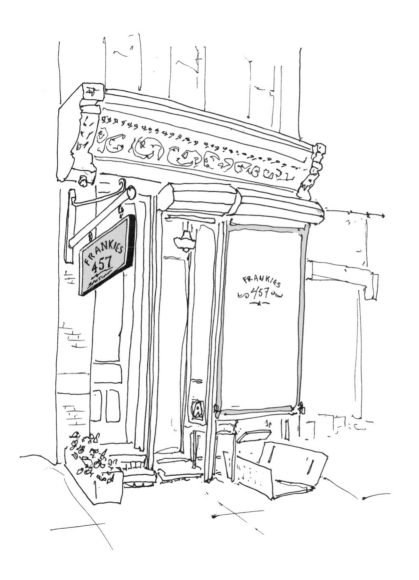

FRANKIES 457 SPUNTINO

457 Court St.

The little neighborhood joint that could, opened by two childhood friends from Queens, Frank Castronovo and Frank Falcinelli, who went on to create a culinary mini-empire.

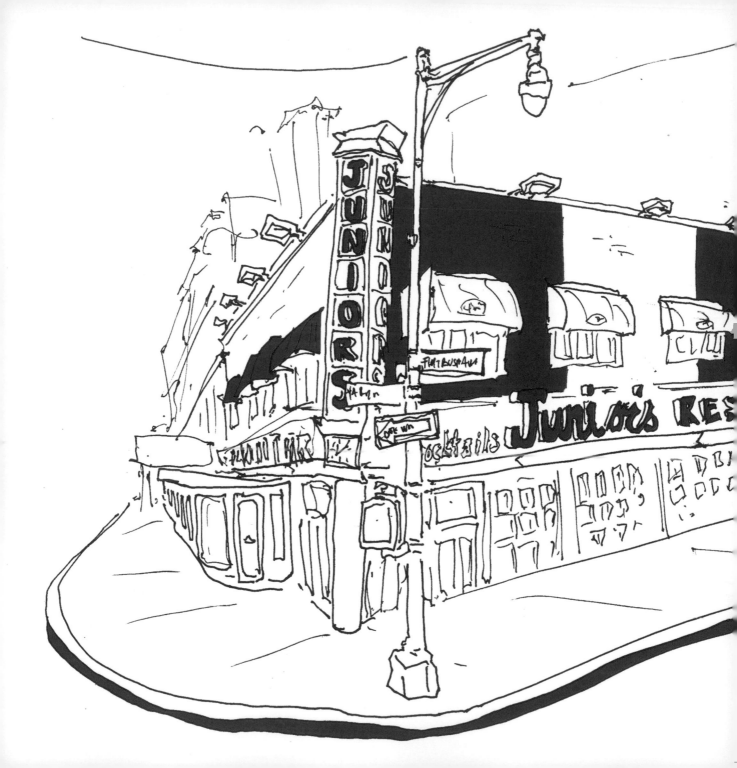

JUNIOR'S RESTAURANT
386 Flatbush Ave. Ext.
Cheesecake

L&B SPUMONI GARDENS

2725 86th St.
Ices, Sicilian pizzas—lots of sauce
and dough, sparsely cheesed—
and generation after generation
of memories

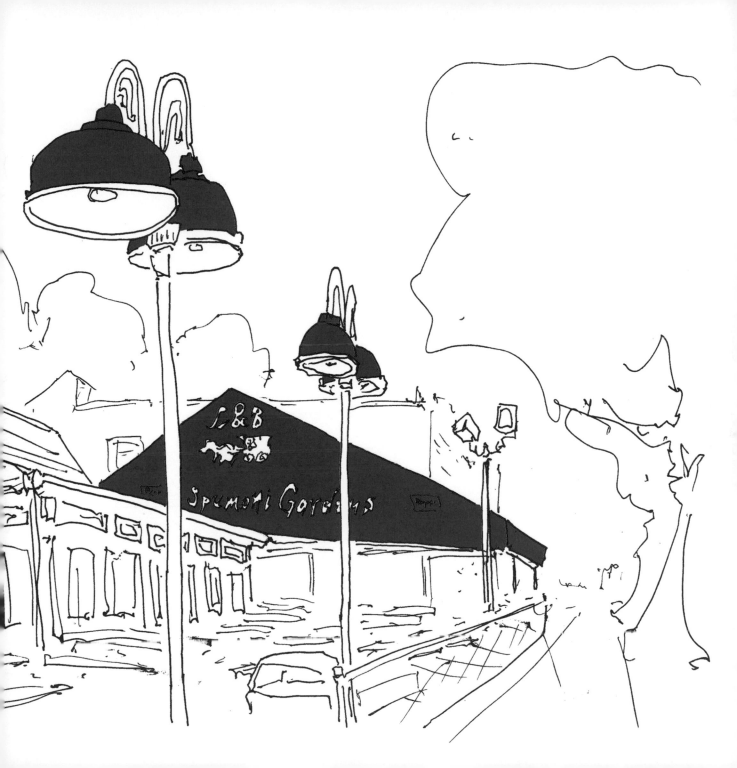

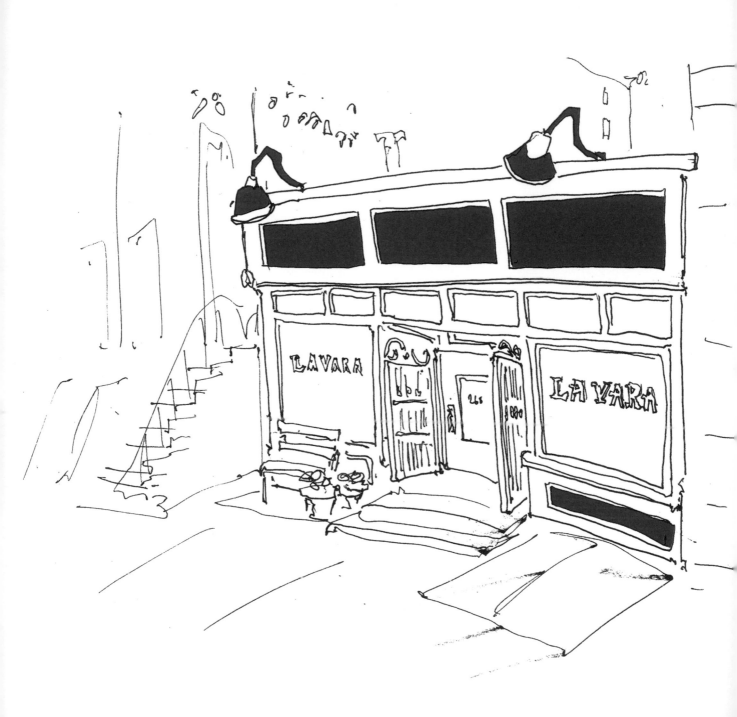

LA VARA

268 Clinton St.
The husband and wife
chefs Alex Raij and Eder
Montero's acclaimed
romp through Spain, with
assistance from Jewish
and Moorish guideposts

PRIME MEATS

465 Court St.

Bratwurst, bockwurst, and knock-
wurst walked into a bar, and out
came this artisanal hall of alpine
delights. It's owned by the two
Franks up the street at 457.

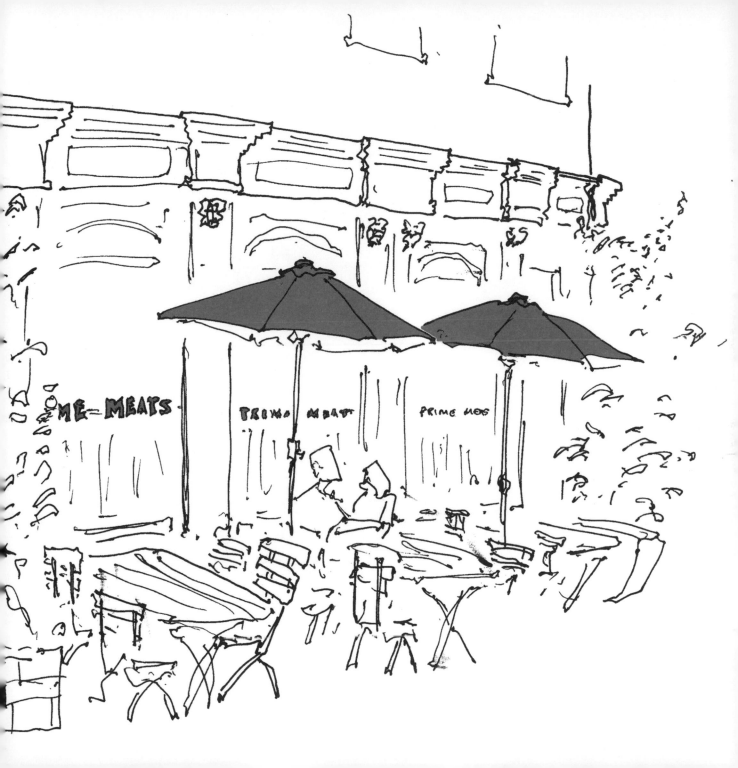

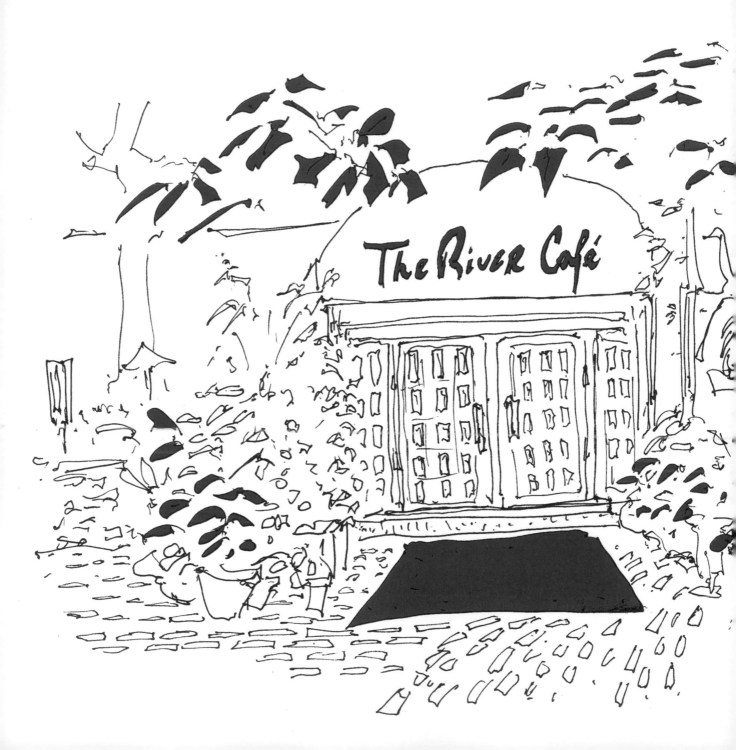

THE RIVER CAFÉ

1 Water St.

New York City's own piece
of prelapsarian paradise,
where on any given night a
handful of couples will end
up engaged. Gentlemen, you
will need a jacket.

BROOKLYN WILLIAMSBURG AND BUSHWICK

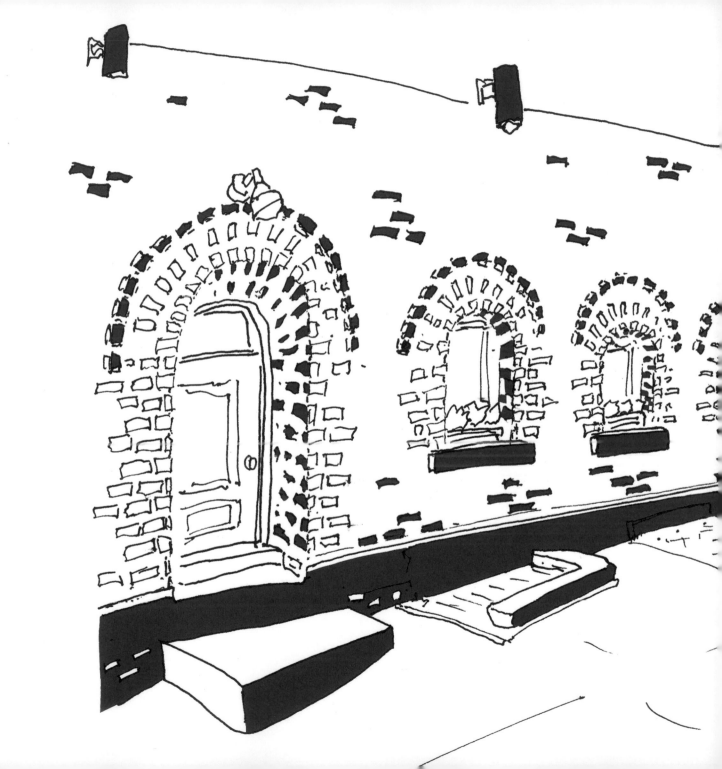

ASKA

47 S. 5th St.
Pigs' blood, lichen, and
other elements of new Nordic
sorcery, from Swedish chef
Fredrik Berselius

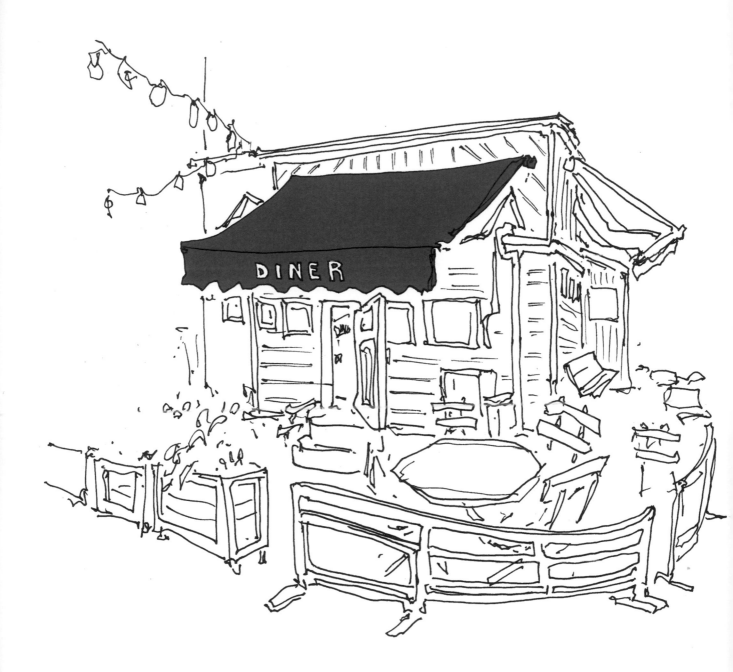

DINER

85 Broadway, at Berry St.
The place where Brooklyn
dining, as it is commonly
understood, was invented.

LILIA

567 Union Ave., at N. 10th St.

When Lilia first opened, I made a reservation a month in advance and was, of course, so excited as the day approached. For a few different reasons, I ended up having to cancel and reschedule twice, so when I finally had dinner there, three months had passed. By the time the day arrived, I was desperate for a bowl of the *malfadini*, followed by their soft-serve gelato. Which I ordered. A few bites into my pasta, I realized I was beginning to have an allergic reaction. I'm allergic to tree nuts and seeds, but the ingredients are clearly listed on the menu: *malfadini*, pink peppercorn, and Parmigiano-Reggiano, so I didn't think much of it. After waiting so long to finally dine there, I continued to eat the entire bowl of pasta as my allergic reaction quickly worsened. The waiter insisted there were no nuts in the pasta and asked the kitchen about it multiple times. By the time I finished, I was really struggling, but I insisted we order dessert. Once we polished off dessert and I was beginning to have trouble breathing, we rushed out to get home. Later on, I learned that pink peppercorn is in the cashew family. That night at Lilia was the last time I ever traveled anywhere without being 100 percent sure I had my EpiPen with me, and I've been back to Lilia and had a snack and drinks at the bar. I have yet to return for a full meal, but I definitely plan on it and have urged numerous different people to dine there as well. And honestly, next time I go, I'm planning to order the *malfadini* without pink peppercorn!
—Rosie Nelson

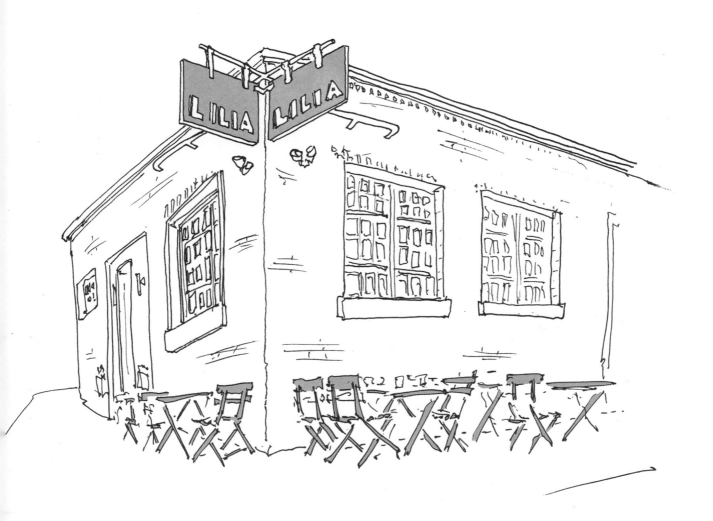

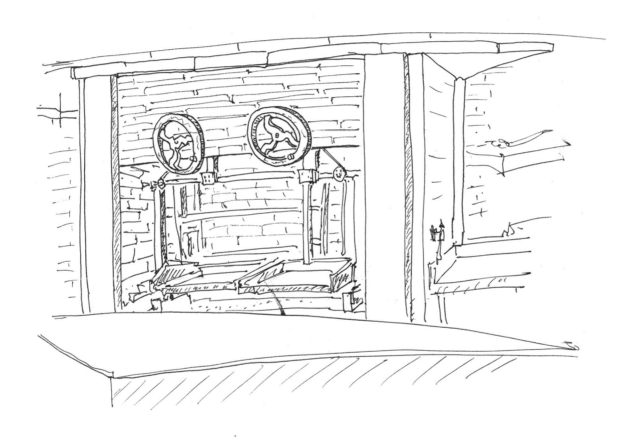

The wood-fired oven at Lilia is the source
of many of its delights.

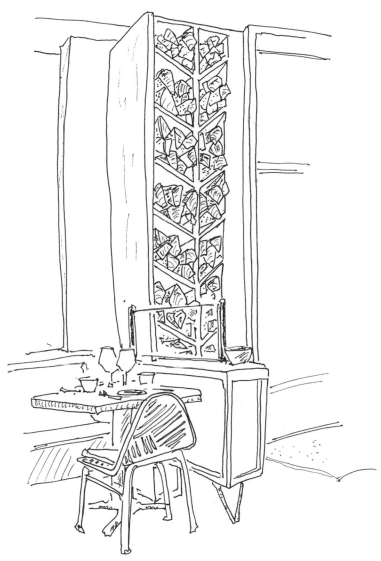

The rustic-industrial decor includes columns
of firewood by the front door.

MAISON PREMIERE

298 Bedford Ave., between
Grand and S. 1st Sts.
Oysters and absinthe

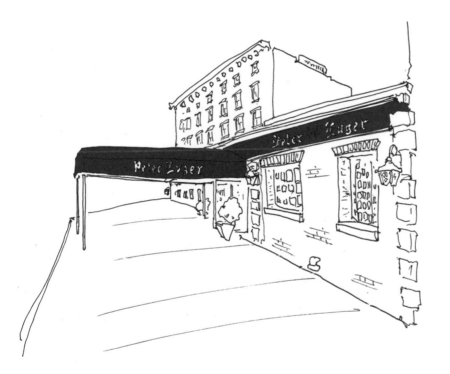

PETER LUGER STEAK HOUSE

178 Broadway, at Driggs Ave.
Life is simple—steak for one,
two, three, or four; cash or the
Peter Luger Card.

ROBERTA'S

261 Moore St., at Bogart St.
Pizza, and a radio station,
garden, bakery, and tasting
room. But really pizza.

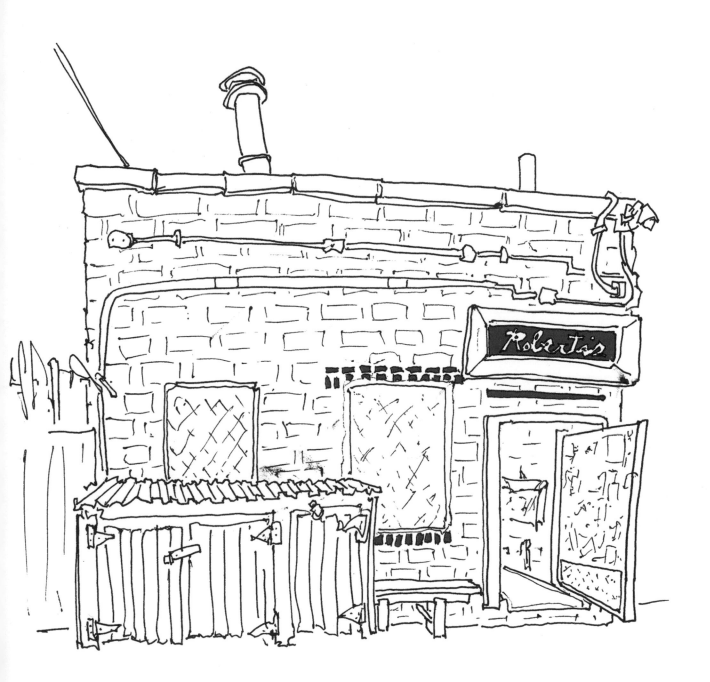

QUEENS

JACKSON DINER

37-47 74th St.

Jackson Heights

The legendary Indian lunch
buffet, and the only reason
many Manhattanites ever set
foot in Queens without an
airline ticket

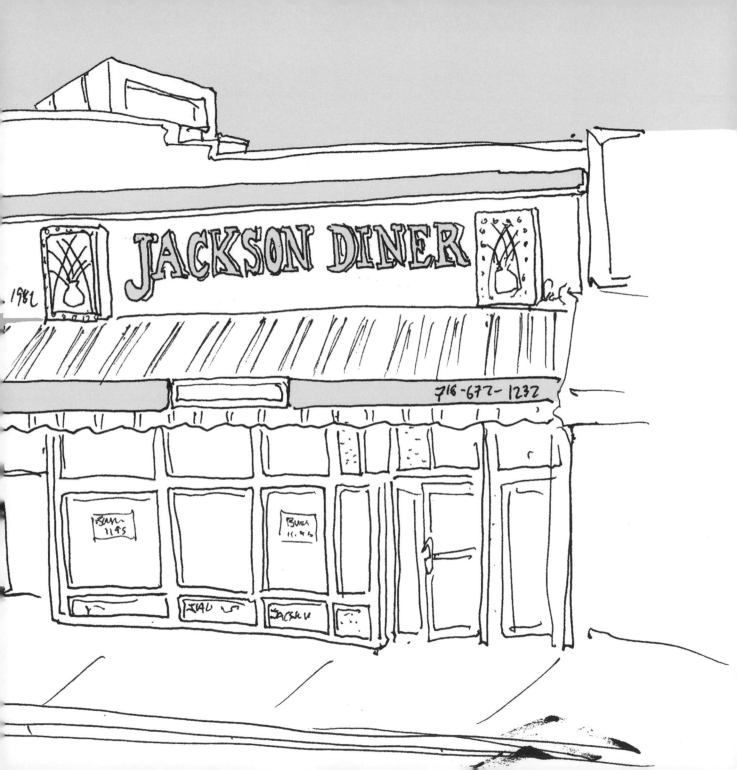

M. WELLS STEAKHOUSE
43-15 Crescent St., Long Island City

Our son-in-law, Jesse, shares his name with an actor and his looks with the captain of the Montreal Canadiens hockey team. We had enjoyed several fabulous dinners at M. Wells, so when Jesse and our daughter got engaged, they wanted to have their wedding at the steak house. Upon meeting them for the first time, chef Dufour declared, "You look just like—" and knowing Dufour was from Montreal, Jesse interrupted him to say, "I know. Just like Max Pacioretty." Jesse works for the New York Islanders and is told this repeatedly whenever the team travels to Montreal for a match. Much bonding over hockey ensued, including a joke that if Jesse arranged for Dufour to ride the Zamboni between periods at an Islanders game, their wedding would be free. Alas, once our daughter told Dufour, "Be careful what you promise—Jesse can arrange that in a minute," they all had a good laugh. Still, the wedding was an incredible bargain, considering the huge quantity and variety of delicious food that was served. A roasted pig's head, the best pork chops ever, and bone-marrow shots to name a few dishes.

—Michele and Paul Sionas

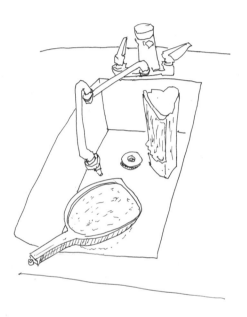

The "log of death" awaits the next order of *truite au bleu.*

"I could skate before I could walk," Hugue Dufour, who is Canadian, said. These hang in one of the restrooms.

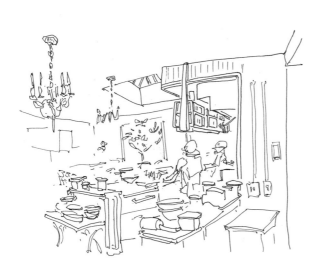

The converted auto-body shop has an open kitchen.

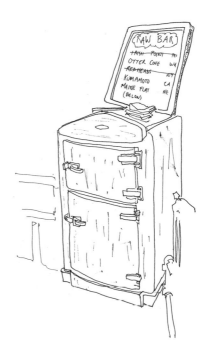

A vintage refrigerator decorates a corner
of the bar area, listing the oysters available.

SRIPRAPHAI

64-13 39th Ave., Woodside
Hot Thai food, literally
and figuratively

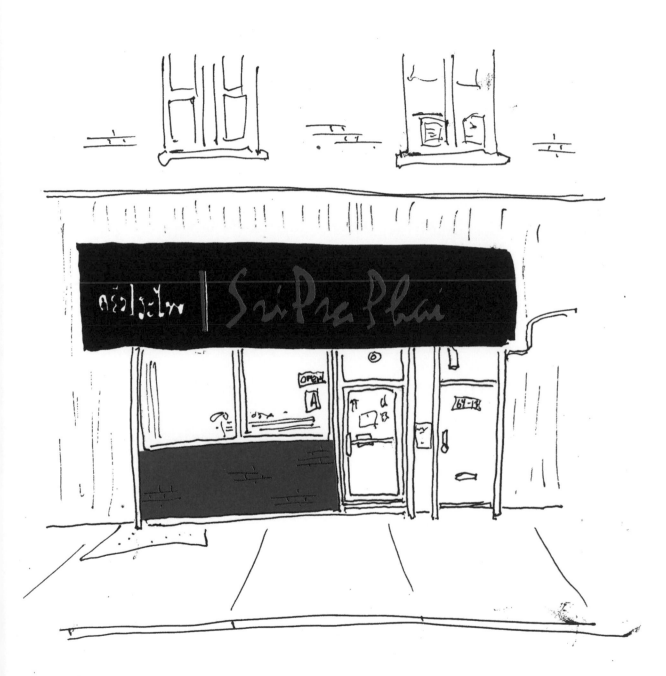

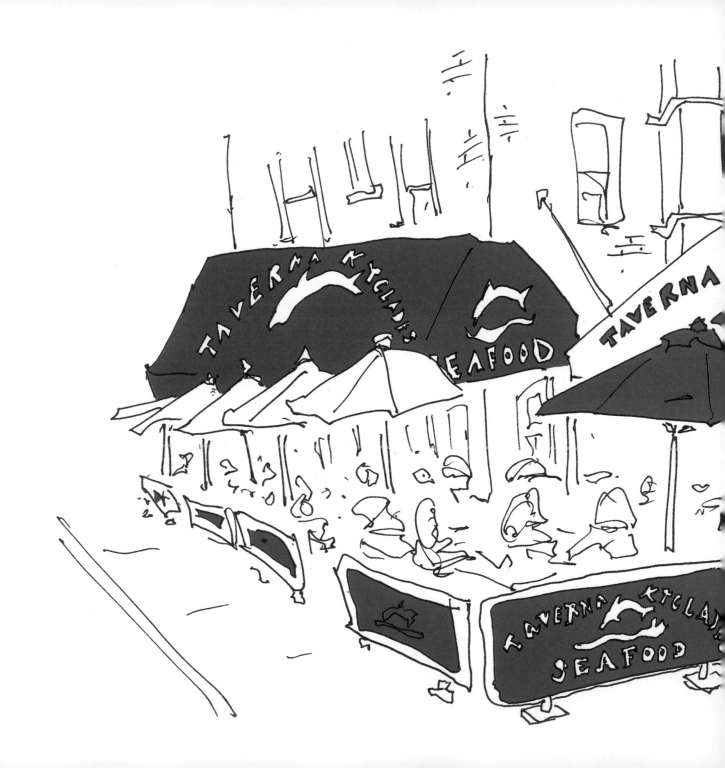

TAVERNA KYCLADES

33-07 Ditmars Blvd., Astoria
During the warm weather, one
can dine alfresco, just like they
do on the Greek islands that
inspired the taverna's name.

THE BRONX

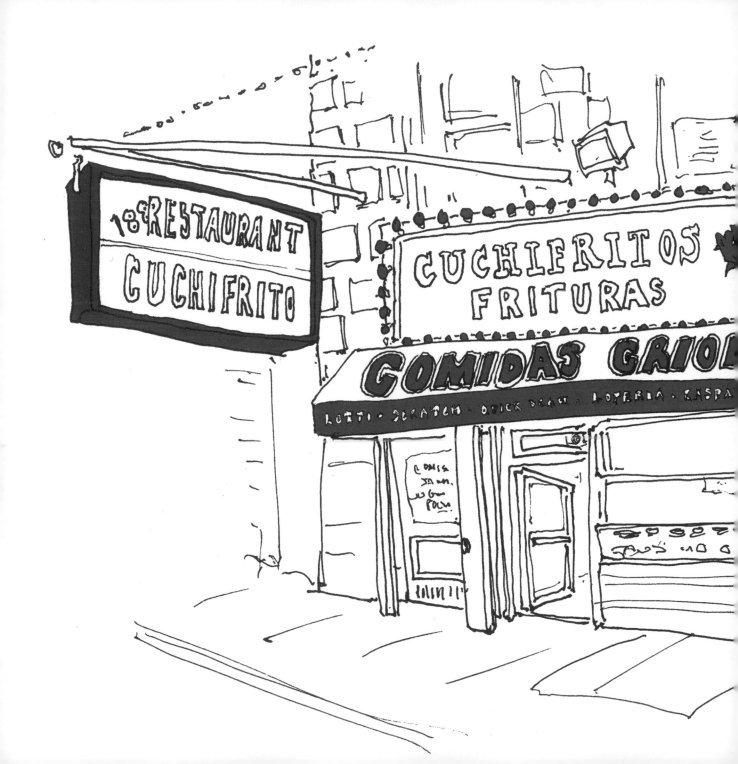

188 CUCHIFRITOS

158 E. 188th St., between
Grand Concourse and
Creston Ave.
Pork, pork, and more pork

ANTONIO'S TRATTORIA

2370 Belmont Ave., at Crescent Ave.

When my son started at Fordham University in 2014, my husband and I visited for parents' weekend. We had heard about the famous Arthur Avenue located not far from campus, and we decided that it was a must-see for our weekend. It was late in the afternoon and we were starving, so we headed down Belmont Avenue toward Little Italy. Luckily, we found Antonio's. There was a gentleman named Joe who greeted us with a huge smile and open arms. Joe visits tables in the dining room, making new friends and catching up with families that have come to Antonio's for years. We finished that first meal with a shot of *limoncello* (house compliments) and were told that our son could come there anytime and he would be welcomed with the same enthusiasm. Joe assured us that he would look out for our son, which was a lovely and comforting thing to hear. Antonio's has been our spot ever since.
—Denise Mahoney

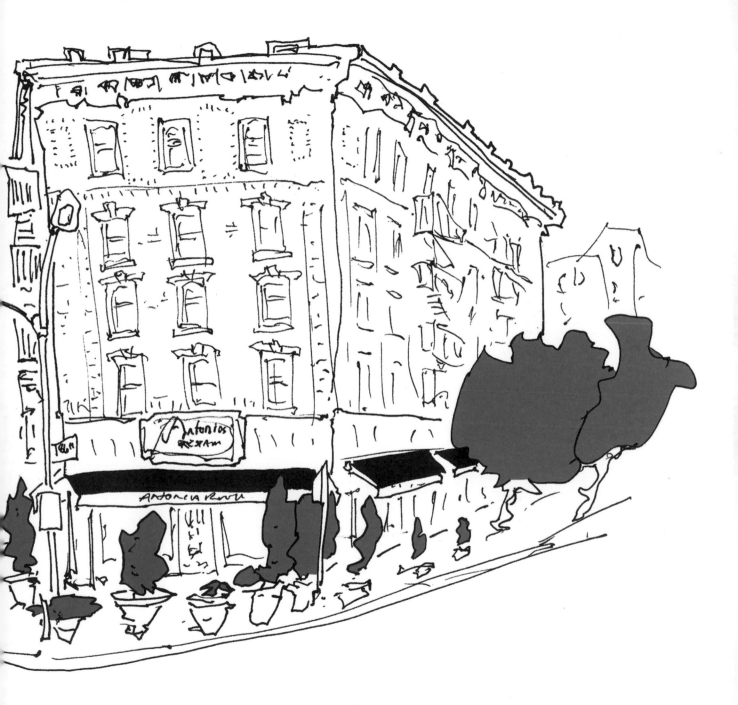

DOMINICK'S RESTAURANT

2335 Arthur Ave.

No printed menus, no seafood on
Sundays, no desserts, and no credit
cards. Instead, long communal tables
and an experience not easily found
anywhere else.

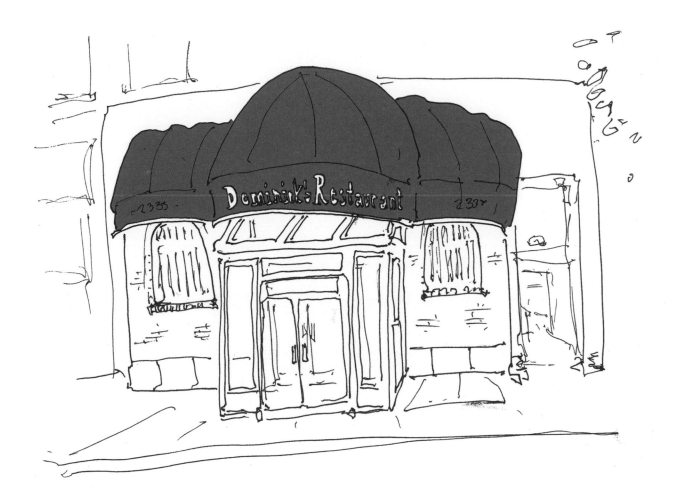

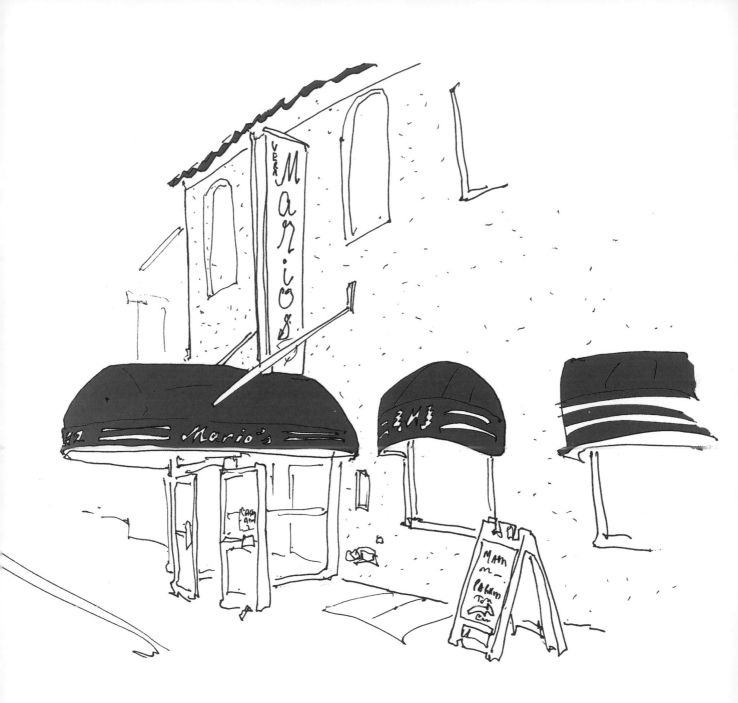

MARIO'S RESTAURANT

2342 Arthur Ave.

Run by the same family for the past hundred years, and most likely the next

STATEN ISLAND

ENOTECA MARIA

27 Hyatt St.

It started with the memory of an Italian grandmother, but now *nonnas* from around the world take turns in the kitchen.

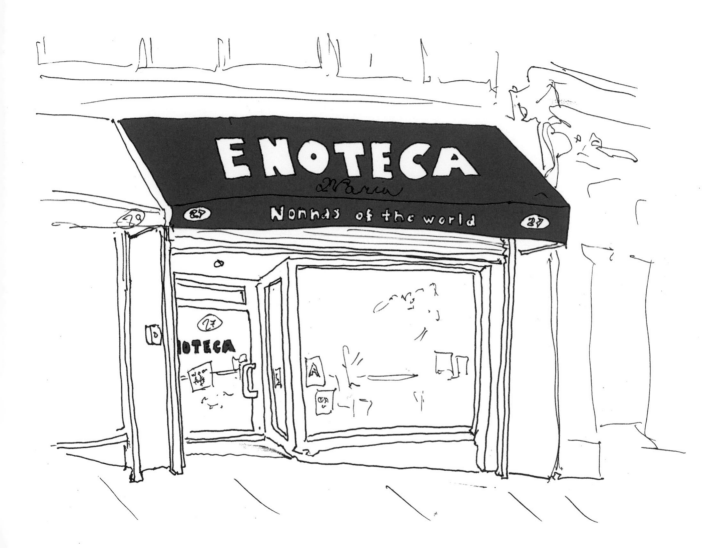

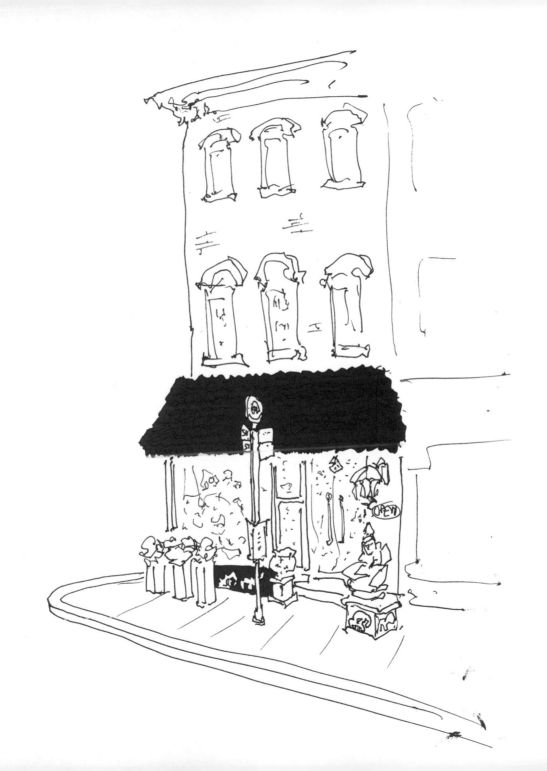

LAKRUWANA
668 Bay St., at Broad St.

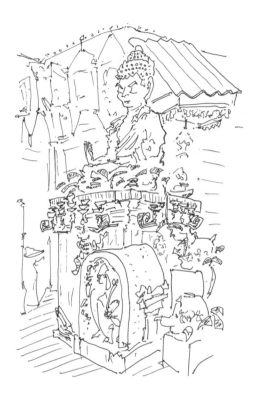

The Buddha is not alone in watching over diners at Lakruwana. Ganesha is there, too.

I've lived on Staten Island for all my life, and I discovered "the Sri Lankan place" when it first opened almost a decade ago. My partner and friends and I were in our early twenties and had never really had this kind of food before. Our taste buds were on fire and we loved it. The decor was so unique and beautiful. The walls are specked with rich red stones called kabok, arranged by bamboo lattice. There are windows and doors with colorful shutters. A portion of corrugated tin roof rings the room, near the ceiling. All around are statues of the Buddha, Hindu deities, and cheerfully menacing Vesmuhunu (devil masks). We discovered the restaurant had a basement where Sri Lankan karaoke took place. Being musicians and artists, we decided to ask if we could have a show there. Best, strangest show ever! Later they turned the basement into a museum of Sri Lankan culture. Now the museum is up the street. Still, to this day the restaurant remains a staple. We take all our out-of-town and out-of-borough friends there when they visit. And it's accidentally vegan friendly. It has an all-you-can-eat brunch on weekends for a reasonable price. There are funny proverbs in the bathroom, with a few lost in translation signs like "Taste yourself, you'll always have a story to tell."
—Phoebe Blue

ACKNOWLEDGMENTS

Many people made this book possible and I want to thank them from the depths of my soul. Without my wife and children I never would have begun. My editor Holly Dolce introduced a vision for this project beyond anything I dared to imagine. Meg Thompson and Cindy Uh brought my work into the world with determination and aplomb. Sohrab Habibion and Rachel Careau were instrumental in getting out of the starting gate. Many restaurant owners and staff, among them Jeff Katz, Emiliano Coppa, Robin Hirsch, and Richard Coraine, were more than generous with their time.

Both Michael Agger, who more than once found my drawings worthy of a wider audience, and Michael Arthur, who provided space to work (along with impromptu Photoshop tutorials), contributed at essential moments. Amanda Kludt was a timely booster as well. And many thanks to Patty Diez, Serena Dai, Melissa McCart, and the rest of the Eater staff (past and present) for the additional support.

Thank you Susanne König for showing my work, Emily Weinstein for making sure the world heard about it, and Florence Fabricant for her coverage. Pete Wells provided moral support and guidance. Chris Crowley aided in this department as well.

Matthew Isreal, John Tebeau, Harriet Bell, Paul Greenberg, Elisha Cooper, Elena Rover, Bob Eckstein, Michael Kaufman, Howie Khan, Zoë Pagnamenta, Helen Rosner, Sally Mara Sturman, Tom Beller, Dan Kaufman, and Betsy Andrews, at one time or another, delivered a key word of advice. Lindsay Bowen provided many. As did Paul Halligan, Erik Gardner, William Stenhouse, Dušan Sekulovic, and Guy Wiggins. Dr. Kamran Fallahpour's contributions are somewhat impossible to put into words. Same for those of my sister Eileen and brother Tom, as well as those of Elizabeth Donohue and George and Jane Schenck. Matt Gross and Ben Greenman offered counsel and did double duty as initiatory patrons. Kevin Conley, Mary Farris, Bill Dreska, and Ellyn Harris deserve note, too, along with Jeff DiDomenico, Milda M. De Voe, and Stacey Sherman.

Huge thanks are due to the staff (current and former) at Brooklyn Community Services, including Janelle Farris, Marla Simpson, and Sonya Shields—along with my fellow external relations and advancement colleagues Kristina, Alison, Kimara, Asea, and Alesha—for the opportunities they have presented. Louisa Chafee was the lynchpin and I'll never forget that.

The amazing folks at Skink Ink, especially Philip, Vera, Brandon, and Robin, really made this project possible. Thank you to the team at ABRAMS: John Gall, Eli Mock, Hayley Salmon, Connor Leonard, Katie Gaffney, Gabby Fisher, and Paul Colarusso. And above all, to everyone who has shared a story, visited my website, or ever ordered a print—thank you.